ALL TOMORROW'S PARTIES

Published in 1997 by
frieze
21 Denmark Street, London WC2H 8NA
Tel: 0171 379 1533 Fax: 0171 379 1521
and
D.A.P./Distributed Art Publishers Inc.,
155 Sixth Avenue, 2nd Floor, New York, NY 10013-1507
Tel: 212 627 1999 Fax: 212 627 9484

ISBN 1 881616 84 3
A catalogue record for this book is available from the British Library.

Edited by Matthew Slotover
Pictures edited by Tom Gidley
Printed in China by Toppan Printing Co. Ltd.

Distributed outside North and South America by Thames & Hudson Ltd., 30-34
Bloomsbury Street, London WC1B 3QP Tel: 0171 636 5488 Fax: 0171 636 4799 and
in North and South America by D.A.P./Distributed Art Publishers, 155 Sixth Avenue,
2nd Floor, New York, NY 10013-1507 Tel: 212 627 1999 Fax: 212 627 9484

 This publication has been made possible by the generous financial support of
the Arts Council of England.

ALL TOMORROW'S PARTIES

BILLY NAME'S PHOTOGRAPHS OF ANDY WARHOL'S FACTORY

ESSAY BY DAVE HICKEY INTERVIEW BY COLLIER SCHORR

Published by frieze, London and D.A.P., New York

Contents

Naming the Colours

Dave Hickey

On a May afternoon, about a month after Andy Warhol's funeral, a friend and I ducked into Fanelli's for a drink after an extended trudge through the galleries. We had been talking about Warhol all day, off and on, and as we sat down, my friend exhaled loudly, wiped a hand across his face and remarked that, judging by what we had just seen, Andy Warhol was not only dead, he might never have lived. 'Yeah', I said, 'but Billy Name is alive and well', and this was so. Easily half the exhibitions we had seen featured samples of the style that Billy Name had all but trade-marked in the early sixties – the grainy, blurry, black and white photograph of dystopian hipsters in their habitat. At this point, however, the style that Billy Name had devised as a stark contrast to the colour-madness of the sixties had clearly devolved into a madness of its own – a kind of visual signature for postgraduate loathing of the visible.

I remember thinking that Billy Name could not have been too happy about this. Then, a week or so ago, I received copies of Billy Name's recently rediscovered and totally engaging colour photographs of life in Warhol's circle, and my first instinctive response was to wish that they had come to light a little sooner. But not a lot. That afternoon in 1987, in the wake of Andy's funeral, would have been fine. Because had these photographs appeared then, before we had so much Jack Pierson and Nan Goldin in our visual repertoire, Billy Name might have had the pleasure of retiring his

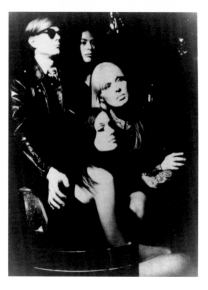

Publicity shot for 'Chelsea Girls', 1967

trademark style, now in its slow-footed decadence, from the track.

Still, it's great to have these pictures now; and even though their very timeliness saddles them with a *post hoc* style that mitigates their historicity, one must admit that, had these images come to light in, say, 1977, amidst the burgeoning 'critique of representation', it's doubtful that anyone would have noticed; and had they come to light in 1968, just after they were made, they would probably have disappeared as well, into the gap between Warhol's oeuvre and Billy Name's own signature images – inundated, on the one hand, by the flood of Polaroids that Warhol himself was producing at that time and simply overpowered, on the other, by the collective aura of the black and white images for which Billy Name is justifiably famous.

The black and whites, of course, were instant classics. First published in the exhibition catalogue of Warhol's 1968 retrospective at the Moderna Museet in Stockholm, they have subsequently become exactly what Warhol intended them to be: official icons in the public imagination, ravishingly seductive advertisements for the corporate culture of the Factory; and as would befit any advertisement for a corporation dedicated to 'getting it exactly wrong', these photographs get it exactly wrong themselves, as advertisements. At the time, they presented themselves as perfect contraries to the crisp four-colour images that promoted 'straight' corporate culture

and distinguished themselves as well from the Factory's own gaudy production – the Marilyns and Lizzes, the portraits and screen-prints – that Andy's enterprise depended upon to 'bring home the bacon' and make the wheels go round.

If you were writing a strap-line to one of these photographs for a magazine ad, it would go something like this: 'Out of these dark environs and the medicated craziness of these wan hipsters, the dazzling icons of American civilisation now issue forth!' Because the image of the Factory created by Warhol's selection of Billy Name's photographs is, first and foremost, the product of Andy's corporate imagination. So it's important to note here that the ultra-cool Warhol, who, in *every* other instance, opted for glamour over sentiment and chemistry over romance, invariably sentimentalised and romanticised the Factory, for reasons of trade, of course, but for reasons of the heart as well.

In the beginning, the Romance of the Factory was the lure, the hook, the loss-leader for everything Andy had to sell – for the public recognition that he sought and all the proliferating projects that he wanted funded. Later, however, after Warhol was on top of the world and encapsulated by his own celebrity, that first Factory on 47th Street remained the only subject upon which he would go all misty and wax nostalgic. It was his baby – the best thing he ever made for the best times he ever had – and he appropriated Billy Name's wonderful images so completely to his celebration of it that

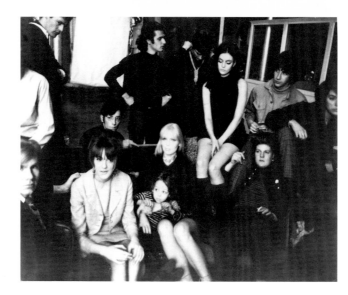

it is almost impossible to *see* these photographs today apart from Andy's almost childlike vision of Dickensian hipsters doing their thing: hustling the Quality, maintaining their sang-froid at the confluence of all the madness in New York, and making the new world. In any case, scarcely an item of published Warholiana has issued forth since then unadorned by Billy Name's black and white photographs or uninfected by their romantic, *noir* ambience, which was, I hasten to note, a big part of it. But it was far from all.

Anyone who was alive in that scene at the end of 1968, of course, can testify to the manic, fatalistic confidence of the zeitgeist, and testify further to the self-conscious sense of living in the midst of history and very near the end of it. 'Here I am,' you would think, 'I'm walking into Max's Kansas City! The fucking hot-centre of everything! How great! There's Robert Smithson, over there, shouting at someone. There's Andy in the back, at a table full of speed freaks scribbling in notebooks. And there's Lou up at the bar, babbling about white magic to Mickey Ruskin. Oh boy! What fun, but how *sad*, too, that as I stand here, looking around the room, my friends are being crunched into red jello in Vietnam; the cops are beating the shit out of people in the streets of Chicago; Russian tanks are rolling through Czechoslovakia, the homeland of the Warholas; Bobby Kennedy is dead, shot down in a kitchen, and

Martin Luther King is dead, blasted on a motel balcony, just in the last few months. And even Andy, sitting back there against the wall in his butterscotch leather jacket, is laced into a surgical corset to keep his guts from falling out … and, Jesus, the little bottle in my pocket … it's running low.'

That was 1968, and in circumstances like these, a certain amount of collective self-pity and *noir* romance was probably unavoidable, but it was *not* everything, and in a very real sense Billy Name's colour photographs give us the rest and the best of what it was. They restore that scene to us where its surface shines and wrinkles, in the midst of New York weather and sixties fashion, in the tactile grunge of downtown Manhattan and the quotidian tumult of quarrels, messy lunches and spilled drinks. And they are able to do this, I think, because these photographs belong to Billy Name and not to Andy Warhol (who is a presence here, but not the cynosure), but also because they are in colour.

Because colour is vision's amphetamine – the attribute of seeing that kills history, abolishes its aura and delivers us into the embodied present. Thus, in an image, it can deliver us, insofar as an image can, not into the grisaille tissues of the past, but into the flash and differentiation of an alternative present – in this case, into the manic and tawdry present of 1968 at ground level. So, Taylor Mead (ga-ga in his red velour pullover) and Viva (prancing around in her aqua lingerie) are not archetypal hipsters

in these photographs, they are Taylor and Viva, out there in the night and on their own journeys, headed somewhere beyond Andy's aura.

Because colour gives us more than characters in a setting, it gives us people with spaces between them. So, even though we can look at the creatures in these photographs and see the attributes that appealed to Andy's sense of social composition, we see their separateness as well. There is Lou out on the sidewalk in his shades, uptight, svelte and self-possessed, like a Jewish switch-blade, and there is beautiful Joe Dallesandro behind a desk at the Factory, Mother's Little Darling come to Manhattan, a perfect double for the young stud in the Bronzino up at the Frick. And there is Billy Name himself, standing in front of Andy's portrait of Sidney Janis, apparently playing himself in a French movie. All of them, it would seem, are telling their own stories here.

So, it is a question of whether you prefer one big story or a hundred little ones. Because Billy Name's black and white images of the Factory tell one big story – Andy's *Hamlet*. If he is not on stage, he is somewhere behind the scenes. If, on the other hand, Rosencrantz and Guildenstern had been issued cameras and were blessed with talent commensurate with their diffidence, their version of *Hamlet* would have looked like Billy Name's colour prints. There would be no soliloquies or duels, no confrontations with the ghost or recitations by the player king. But we would get a real sense of the

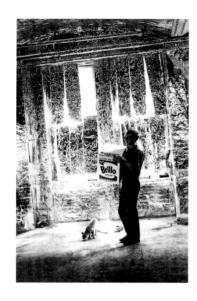

Andy Warhol with Brillo Box. Factory 1963

party after the play-within-a-play, and gain insight, perhaps, into the life of a spear carrier. And later, with luck, we might catch a glimpse of Gertrude in her aqua lingerie trotting down the hallway to the loo. Then, comparing these little stories with the one big story, the elegant tragedy, we could sense the ruthlessness with which great art imposes itself on the world; we could *feel* what it suppresses, and sense as well the quotidian sociability that good art invests with equal value.

So, now, at this moment, there are two Billy Name photographs pinned on the wall above my desk. One is a black and white from 1963 of Andy Warhol carrying a Brillo Box across the 47th Street Factory. The walls behind him are silver (as is the cat on the floor, I suspect). Andy is probably getting ready for his Stable Gallery Show, and the depiction is wonderful: it captures Warhol's sensibility and documents a special moment in the history of twentieth-century art that, like Andy, is lost to us forever. The second photograph is a colour print from 1968, taken on the diagonal, of Andy emerging from the bathroom at the Factory. He is wearing blue shades, blue jeans, a blue turtle-neck and a brown leather jacket. He is wiping his hands on a paper towel. And that's it, but I like the second picture better. It only tells us that Andy Warhol took a leak in 1968 and washed up afterwards, but the fact remains that the first picture reminds me that Andy is dead. The second reminds me that he used to be alive.

A Talk with Billy Name

Collier Schorr

Andy Warhol filming 'Loves of Ondine', 1967

How did you become the Factory photographer?

I first met Andy in 1960 when he was a commercial artist. He was very successful and I was a waiter in this coffee house called Serendipity where he used to go in the evenings. We met again, a few years later, when I was working as a lighting designer with the Living Theatre and the Judson Dance Company. I was hanging out with Ray Johnson, the collage artist, who along with Andy was doing covers for New Directions paperbacks. Ray brought him to a haircutting party at my apartment. At the time I was the haircutter for people in the arts because we never went to the barber's, we'd always find somebody who had a knack for cutting hair.

There's that great picture of you cutting hair on a fire escape.

With Edie and Ondine. So, someone would say 'Billy, I need a haircut' and I would say to come over Friday around nine. And everybody would know about it, and so maybe 150 people would be there, just being cool, like at a hair salon.

And did you get any money?

Nobody had money in those days. Andy made a lot of money as a commercial artist, but he bought a townhouse. Most of the artists in the scene didn't have any money and we always collaborated with each other, did things for each other. At the time of that party I had foiled my entire apartment, I had beautiful theatre lights, and everything, including the silverware, was painted silver. Andy had just gotten his loft space for his factory on 47th Street and he said 'Billy, would you do this to the loft I just got, because it's real dingy.' Andy didn't just see a guy's place and think 'That's real cool – he's got foil all over the place'. He saw that I had done an installation. This was also the time when Andy got his first movie camera. He had been carrying around a Honeywell Pentax 35mm SLR but when he got the movie camera he handed me the Pentax and said 'Billy, you do the photography now, because I'm going to do movies'. This was in 1964. Eventually I moved into the new Factory because I was up there working all the time anyway.

Did Andy have any idea that this was something you wanted to do?

He knew that I was already trained in theatre, so I could do lighting, sets, direction and design for staging. I was actually the first set co-ordinator. People who were in the films needed a few cues or a few words to feel comfortable, to get in the groove of what we were doing.

17

So it wasn't that much of a stretch to then take up the camera?

No, it just gave me an instrument to record what I was setting up and doing.

What did you see as the role of the camera in the factory?

Cameras were as natural to us as mirrors. We were children of technology. When Norelco gave us their first video machine, it was like someone getting us a new pair of shoes. Andy and Robert Rauschenberg and Roy Lichtenstein had let it be known that technology was now a part of art. There was this project called EAT – Experiments in Art and Technology – where artists were introduced to scientists and engineers to make artworks. That's where Andy met Billy Kluver (from Bell Labs), who eventually made the silver clouds with him. Andy was fascinated with anything technological. It was almost as if the Factory became a big box camera – you'd walk into it, expose yourself and develop yourself.

So people assumed they would be photographed when they walked into the Factory?

Oh, of course.

Did you see yourself as an extension of Andy?

No, you didn't really do that with Andy. You were part of the Factory, not part of Andy. The way I analyse what I did was that I was like a journeyman. It was my duty to be Andy's arms and legs. That was part of the role I played at the Factory. I was usually so synchronised with him that he didn't have to tell me what he needed, but I was aware that if he was working with someone who wasn't in tune with him, he'd say 'Oh, no no no', and tell them precisely what to do.

Andy had an image in his head and you were able to see it?

We both had an eye, but it depends on the medium you're working in. When we were making a movie, I never did the camera, but I did the lights and sets and I knew the film and I knew how the camera worked. If you understand these equations, you know what you can capture – you know the range of black and white or colour in it and you have a style where you select a range of hues and tones and type of shadows and chiaroscuro. So it's in setting this stuff up when you all decide what you want it to look like. It's much more in the mechanics than the aesthetics of it. The aesthetics you have in common, it's the mechanics that allow you to realise your aesthetic, to make a style.

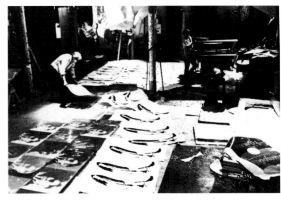

Andy Warhol, 1967

In the song 'Difference Between Wrong and Right', Lou Reed sings, 'that's the difference between wrong and right… but Billy said, both of those words are dead'. Did you really say that?

Well, Lou and I used to have these very – you might call them occult, Zen-like, thought conversations. We were always on the same level, we could intuitively hear what each other was really saying in that cool Zen way. And I always talked like that in those days.

You look so quiet and peaceful in those early pictures. You seem to have pre-dated New Age.

But in a New York way. I had been out to the West Coast when I was 19 or 20. I was living in San Francisco and Topanga Canyon with the poet Diane DiPrima. Freddy Herko was there too. I got to know a lot of West Coast artists and I really loved their spirit, their communal way of relating to each other. Everybody was of the same rank, and that equality was something I really fell in love with.

It seems that in the Factory, everyone was useful, rather than important.

Well, the Factory was a very functional place. Andy provided an unpressured arena where people could come and play and work and the only qualifications were that you had some speciality, some beauty or some talent. If you did, you could just hang around and be in the films when we made them. I was skilled in the technical aspects, so were Gerard Malanga and Paul Morrissey, but then other people, like Ondine or Edie (Sedgwick) – they were skilled at being very special people. Whatever skill you had allowed you to fit naturally into what we were doing. There were a lot of people who came and just immediately left, or who came and had trouble for a while and then realised that they weren't up to the level we were working on. So in that sense, the New York scene did have a ranking to it.

Was Edie as beautiful as she looked in the early pictures?

Oh yes, she was absolutely delightful. Not only her physical beauty but her inner balance and poise. When you were in a room with Edie, everyone was on point because they could feel her excellence. Apart from her beauty, there was a feeling that she was capable of directing anything. When I go to colleges a few girls will always come up to me and ask that question. There

Edie Sedgwick screen test, 1965

19

were many striking women in the Warhol films – like Susan Bottomly (International Velvet). She was the most beautiful and she was very young, she was only like 16 or 17. Nico was gorgeous. Viva and Ingrid Superstar, who both had beauty, were more like the comediennes, like Lucille Ball.

Did people compete to be famous?

Not really. Because if you were able to maintain your level there, keep up with everything, it was more of a club of actors. We all respected each other and knew that it worked better when we admired each other and played as a team.

And it was important to be famous?

It was important to have a place to work, which wasn't a nine-to-five thing – because none of these people could ever have a regular job.

So, was Andy paying them?

No, but he paid the rent on the place and he would buy food sometimes when we needed it. There was no cash flow to pay anyone. Especially when he started making the films which were so costly. All the money he got from selling the paintings went into making the films.

What did you do for pocket money?

Um, I forget. We all had apartments and we went from pad to pad. We were all just making art and hanging out. We never bought anything. The funny thing is, you didn't need money then. Claes Oldenburg opened up a store on the Lower East Side and called it 'The Store' but when you walked in you realised it was a huge piece of art. That's what our world was like, we were on an acid trip. Money was of no consequence. That's why the Velvet Underground never really made it, because they were really artists with that same sensibility of being in a trash civilisation. It was a shallow culture not worth attending.

Did you have to take drugs in the Factory?

No, you just wanted to. They were fuel. Tripping was cool and we used it to be better than the good we already were. LSD was a whole other level of experience. It's like being in an earthquake, because all the parameters that you live by are gone. When a solid terra firma isn't there any more, you're all of a sudden nowhere and everywhere at the same time.

That sense of being somewhere other than on the ground really comes across in the Bathroom series.

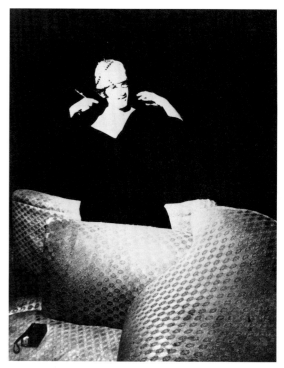

Ondine as Pope Ondine in 'Chelsea Girls', 1966

I'm very much interested in portraiture, not only of people but of space, or people in spaces. I was interested in using angles to make the structure evident, like looking at form in an abstract painting. Although these are representational, when I take a picture, I'm usually looking at a certain structural composition of the whole thing that is going on live, and when it's just perfect my finger pushes the button. I was trained in collage and I worked with painters, so I always saw that way. The camera, when I first started using it, wasn't just about snapshots. I could see things that were matched to my aesthetic framework in that click. Then I'd develop the negatives and they'd come out great and I'd do the prints and it was just heaven when the image came up. It's like saying 'I wanted to have a child and this is just the one I wanted'. And I'd be so happy.

What music were they listening to at the factory, besides the Velvets?

In the early sixties while Andy was still working in his townhouse, he had a studio behind the one where he did the commercial work. There were huge rolls of canvas which he would roll onto the floor and do his silk-screens – he was doing Elvis at the time. He always had things on like *Sally go Round the Roses* and Motown-type music – '45s. Even at the Judson Church, after the happenings or the dance concerts, we would go down in the basement and someone would be the DJ and all the artists would just dance to the Motown records. It was all groovy stuff. At a certain point when Ondine used to come up to the factory, Johnny Dodd, Ondine and I used to take acid and play Richard Strauss's *Electra* over and over until it became part of our bones. Henry Geldzahler, Andy's best friend at the time, had a great collection of opera. Eventually I installed one of Andy's hi-fi set-ups in the Factory and I would bring records, or Henry or Ondine would bring theirs over. Of course, when Ondine was there it had to be Maria Callas, because he couldn't tolerate listening to any other singer. I loved her too, so I didn't mind.

What did you all think of the Beatles?

A little squarish, you know, but brilliant. We knew they were being very creative and doing nice good new things in music. And that they were obviously open-minded people – they took acid and all of that shit. So many people I knew in those days, younger people, say 'Oh the Beatles were great', but you know,

they didn't move me. We were New York people, we dug the Stones more than the Beatles because their music was more dangerous and sexual and rhythmic. When we were relaxing we liked to groove in that earth groove, more energetic. The Beatles were more intellectual.

In Oliver Stone's *The Doors* there's a scene when the band comes to visit Andy at a Factory party and the band, except Morrison, is really freaked out by the decadence.

It wasn't really like that. At a certain time in New York, if you were of any significance in the cultural scene, you would go to the Factory, and we were important at the time. It was a place where the current creative people could meet. There was nothing cheap or chintzy about it, other than we all liked kitsch. When Morrison would come over we would feel really great about it because we knew that he wouldn't go just any place and that we had a place where people of his calibre met. Rudolf Nureyev and Judy Garland and Tennessee Williams weren't slumming or anything when they came to the Factory, they were just meeting peers. At that time we had that real catalyst going on, we were in the hot centre. It wasn't the political world, or even the social or literary world, it was the world of creative artists. It was a place of high enough magnitude and authenticity that people could come and be comfortable. And when they came there, they were just like us.

Who was the best boy?

Well, in terms of being the best subject for Andy's films or my photography, I would have to say Joe Dallesandro. Because he's such a natural. He's very poised and balanced in an authentically New York way. He's not an intellect. Gerard was a very beautiful boy too, but he was a poet, a literary person who had his own aesthetic intellect. Joe was just a raw person.

His ego must have been simpler to satisfy.

There was a lot of competition about how things would go direction-wise, between me, Paul and Gerard and later on Fred Hughes – whoever were Andy's men. We all had our ideas: we never argued but you knew that in order to get it to come out the way you wanted it to, you had to be there all the time, be the one doing all the work – taking care of everything. Now, Joe was the kind of guy who was just there almost as still life, a beautiful subject to record. So in a sense, that's why he was the best boy, because he wasn't competitive for an outcome with you. He

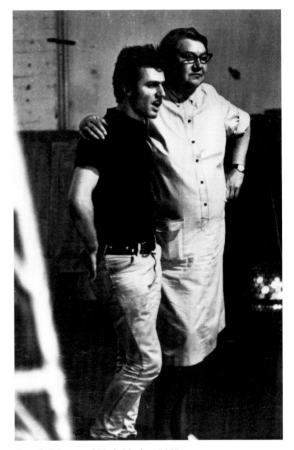

Gerard Malanga and Marie Menken, 1965

didn't try to take over the technical controls of things. Whereas Gerard was both in the films and wanted to run them too, and I was in a number of them too and always wanted to run everything. Paul wasn't really in any of them, but he always wanted to run everything. We were the kind of guys who were very skilled and could handle the whole thing, each one of us, even if Andy wasn't there.

I love the picture of Jay Johnson coming out of the bathroom – he looks like he could be coming out of the boy's room after football practice.

That's true. In some of them, you can see Andy's painting off on one side, but most of them you don't know where it is. Because it's a faceless scene, so to speak, the personality just comes out so naturally that you don't know where it would be. I did the bathroom door series as an intentional photo essay; there are probably like 50 or 60. I like the group pictures in front of the door with Andy and Brigid, or with me and Paul and some actresses, they're very New York looking. They're dynamic because these people were interacting, but not paying any attention to me, like I'm not there.

There's not a lot of tragedy in your pictures, even though I've read about a lot of dark stuff connected to the Factory. Did you choose not to shoot situations that were particularly harsh? Were there things you didn't take pictures of?

No, there weren't things that I wouldn't take pictures of, but I did look for that joyous youth thing, that exuberance that you get with artists playing and just being with each other. When they are with each other – artists in the same field, of the same magnitude – life becomes joyful. The only real tragedies, except for the shooting by Valerie (Solanas) of Andy, were the personal tragedies that we all go through, that you experience simply as growing and as life. We always knew this. Some photographers find a great beauty in grotesquery and can capture that in photography and you can see the beauty of it. Some of Nan Goldin's work is like that.

There must have been some grotesque things that you didn't photograph.

Well, I have photos of Ondine shooting up on set, there's *Chelsea Girls'* ugliness, there are shots from *Hanoi Hannah* with Mary Woronov whacking Ingrid around, all those funny things, but

because we staged it and then let it happen it sort of became part of a film or an artwork, so it's not grotesque anymore.

Maybe one of the differences is the level of innocence; certain stuff had never been represented before, in a mainstream way. Certainly, *POPism* and the Factory Fotos and films introduced some of the imagery that then fed into someone like, say, Goldin's documentation.

The thing about the Factory was that we did it our way, not to anyone else's standard of what a studio should be like. And we insisted that anyone who became part of our scene be what they are. That was one thing that Andy would always say. If a person did something special, he would say, 'Oh would you do that in a film?' It was innocence, yeah, but it was natural innocence, because New York had just become the centre of the art world. Since it was a new era for the city, the artists had to set the tone. It wasn't set by museums or curators or critics, it was set by people like Johns, Rauschenberg, Oldenburg and Andy. These people's natural right became the rule and it had to be done their way, without restrictions.

Which photographers influenced you?

I wasn't really looking at photographers' work, more painters'. I was brought up in the Abstract period, so I know their aesthetics – colour, form and composition. When I started working with Andy we would go to Rauschenberg's studio to see what he was doing, he would come over to see what we were doing. Film, photography and a little later, video were just tools artists were using. The underground film world was just beginning in New York. It started out as abstract filmmaking, where artists would paint on the frames or make highly edited, structurally abstract movies. Film began to turn into art and that's what Andy became fascinated with. He sort of peaked when he became famous for his paintings, and after a time he didn't get the same thrill that he used to. He wanted to do the same thing in film. He thought he could strike the same pinnacle. He thought he could take film as a medium for everybody in America to see as art.

Tell me a little bit about the way you arrived at the diptychs.

The camera is an Olympus Pen-F, from 1968. I got two of them when they first came out. Andy had a deal with a guy who had a merchandise store down in the Carolina's – we ordered things from his catalogue, and Andy gave them paintings in exchange.

So why did you pick that camera?

Because it was a half-frame camera. It's interesting to play with because you get 72 pictures from a roll of 36-exposure film.

When you were looking through the viewfinder, what did you see?

You see a regular 35mm image that's half the size. To make the diptychs, you can couple a print with the one before it or the one after it – conceivably there'll always be that choice. In fact I never printed these myself – last year I took them to a local lab and I just gave them all the negs and I said 'Do this on one of those automatic printing machines'. So the machine pretty much determined what would be with what.

After seeing the prints, were you tempted to go back and play around with different combinations or were you just happy with what came out?

That's the thing. My eyes just popped. I said 'My God, what beautiful colourful images, and they're so cool'. Because I was raised in the John Cage, Andy Warhol school – like Cage with his chance operations and Andy with 'machines do the art' and all that stuff. Since the machine they were using was for printing 35mm film it naturally did a whole frame which included two of the half frames. So I thought, 'This is fine with me. I'll just leave them like this. I really wouldn't have thought to do this. The machine did it fine and I'm really glad'.

They certainly have that sense of chance.

I know, because with them, one is vertical and one horizontal too. If you don't insist on being too conservative and too picayune… all the people I've ever worked with, from the time I was a teenager, were the avant-garde experimental people. I'm not all trained like someone who knows exactly what they want and then orders it from a lab. All I ever said was 'do not colour-correct, maintain intense saturation and high contrast'. Those were my instructions.

What strikes me is that with the black and white work, when you were making prints for actors and visitors to take from the factory, you did crop in the darkroom.

Well in the early vintage prints I did crop or enlarge some of them, but ever since I did the Stockholm catalogue I printed everything full frame. I never crop or enlarge a detail. With the early work, I was doing what photographers did at that time. If

Silver Cloud on Factory Roof, 1966

you had a negative and a certain portion of it was great, then you just blew it up. It made a very uneven product, but that was the tradition at that time. Now, when I print everything full frame, they have a continuous style or look to them.

It seems as though you were working in-between a number of traditions. You had this idea of mastership from Black Mountain College and you were also part of a world where people were just throwing their talent up on the wall.

I like to work with the fundamental. For instance, when I silvered the factory, it had to be the whole thing. Once I'd printed the Stockholm catalogue full frame, I finally realised how wonderful it was to work like that – with as little tampering as possible.

Do you see pictures being taken today that remind you of what you were doing?

Oh, I see a lot. I mean there are so many artists who have shows at the Whitney or MoMA who do a lot of what I did in the sixties, but because I was incorporated into an art scene – the Warhol Factory – I was never viewed as a photographer independently.

Did it surprise you that the colour photographs look so contemporary?

Ah, it did because I never printed them until last year. At the first Factory I shot everything in black and white and always used available light or else the lights we were using for films. At the second Factory I got a flash, a big powerful one, and decided to shoot some colour.

And you never printed them?

I printed some of them – the Velvet Underground album cover shots, which were the only commissioned work I ever had. Even though they were shot in colour, the shots of the Velvets on the third album were printed in black and white because I didn't have a colour enlarger. We were still short on cash flow and I couldn't get Andy to buy me this stuff. I thought 'well, if I do the album covers maybe I could get a colour enlarger', but they were very expensive then. It wasn't until well after Andy died and they found a trunk with all my negatives and a lot of prints in it, that I had them again, and I just let them sit for a while.

It's nice that they gave them back to you.

Well, you see, it's not that they gave them back to me – it's that I am 'they' too. Sometimes I would just do a whole box of 11x14 inch prints of select shots of the films we had done in the past six

months, say, and put the box on Andy's desk.

And what did he do with the pictures?

Well, I don't know. They're finding some of them in the Time Capsules that they're opening at the Warhol Museum. Originally, when I put them out, a lot of people would just take them. I would make prints of all our film stars, and of Andy and the artworks. When Ivan Karp, Sam Green or Irving Blum brought patrons over, they would just go through these boxes of pictures and be delighted.

So it was like a stock house?

They were more like the Factory album that was available to people to get a more extended view of what was going on beyond the day they were there. The irony of the Factory situation is that even though we were one of the true artist groups, we presented the individual persona as an art object. Andy was fascinated with making glamour. He loved the Hollywood movies so much because of the glamour – people were just drawn to it. He didn't actually say this, but he wanted to figure out how to do it: to figure out what glamour is composed of. So that's what he did with Edie and Nico and the type of glamour that the Velvet Underground came to have. He moulded it like Disney made cartoon characters. We would make clay models of how we wanted Edie to develop, what we wanted her to be. We developed this kind of glamour of individual personality and eventually Andy became the epitome of that himself, which wasn't what he was trying to do – he was really trying to create it as an artwork, but he was so into it that he became fascinating to people himself. He always wanted to be famous or known as a great artist, but it turned out that his attempt to discover what glamour was encompassed him too. Then he over-glamourised everything he ever tried to do. After Andy, a lot of younger people thought that was what artists were.

Was Andy attractive?

He was almost repulsive in the physical sense, but he had an intense charisma. Like, if you went into a gallery and Andy was there, there would be an electricity going through the room, everybody would notice that they were in the right place and then you'd go over to him and he'd be like some synthesising catalyst. Anything you'd want to do would just melt into what he was doing at that moment. It was like being in a black hole,

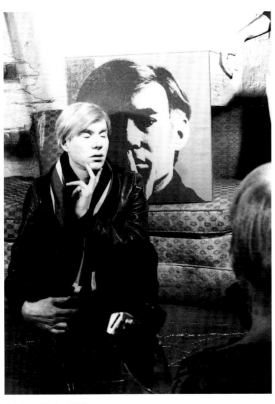

Andy on Andy, 1967

everything fell into him.

Was he greatly disappointed that he wasn't pretty?

It seems to be part of his personality complex. The real Andy, the artist, the guy who just really liked to make art wasn't really concerned about how he looked, but the guy who came from Pittsburgh to New York had to compete in the New York art world, where people were fascinated with beauty. You know, like in Hollywood, you had to sleep with the producer in order to get ahead. And you also had to be beautiful. And he wasn't that kind of beautiful. He was like a kid with acne who almost looked good.

Did he encourage you – did you look for other venues for your work?

Yes he did. He did that with all the people who worked with him. He had this great work ethic, because he made it on his own.

Was everyone as nice as you are?

No, no one was. It was my role, to provide a sense of stability for people. It was about being the one who could co-ordinate things if someone was too busy, or it was just too hard, or they couldn't handle it. I could do anything from installing the electricity at the Factory to lighting the set.

Were you the only butch one?

Well, Gerard's sort of butch, isn't he? But, yeah, I'm a pure butch.

When I look at the old pictures there were so many girlie boys.

It wasn't safe for butch gay boys to come out in those days – the gay revolution didn't start until after the mid-sixties. It wasn't in their nature to flaunt it or to be faggy. There were a lot of gay boys who would never put on a dress or ever play the queen. Eric Emerson was almost butch, but he was very beautiful and he was a dancer.

Was there a lot of swinging and wife-swapping?

At a certain point, maybe for two or three years. There was a three year period where all you did was go to bed with everybody you ever wanted to.

Glenn O'Brien said you sat in your darkroom reading astrology books.

Well, I did. Not only that, but I would cast charts. When Viva wanted to know if she should get a nose job, I cast a chart for her. And it came out 'no'.

Did it feel different when you were taking pictures away from the film set-ups?

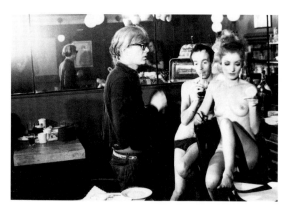

Andy Warhol, Taylor Mead and Viva on set of 'Nude Restaurant', 1967

I always carried my camera with me wherever I went and I did spend time outside the Factory scene. I had the keys to Henry Geldzahler's apartment – he would pay me to do light housekeeping when he was away for the weekend. He also wanted someone there to guard the place because he had all these valuable Johns and Frank Stella paintings. When I went to Henry's I was a different person, but I was still Billy Name and I still had my camera and I still photographed. Eventually I had to be Billy Name on my own and I started doing that before I left Andy's.

Can you see a difference in the pictures when you were outside the Factory?

There's a little more grittiness. Because in the first place, I didn't have the lights we had at the Factory. I wasn't using a flash. When Tri-X came out, it was a fast enough film that you could work with available light, which is part of what's now called the 'sixties photography' genre. The whole *Nouvelle Vague* was possible because people could use hand-held cameras and available light instead of having to do something in a studio or a well-lit setting. So all that French New Wave film was going through the same revolution as photography in New York.

How did you get the name 'Billy Name'?

Oh, I made it up. When we were touring with the Velvet Underground we had a show called *Andy Warhol Uptight*. It would consist of the band, and Edie might be dancing, and Paul and Andy and I would be doing all these light effects with strobe and colour – it was like an early multimedia show. Eventually we brought it to The Dom on St. Mark's Place and it became the famous Exploding Plastic Inevitable. So when we first started doing this at various colleges, part of it was also that whoever came to these events got to be part of the film we made during the event. So everybody's name would be on the poster and when I looked at the poster I said 'Billy Linich doesn't really look like a poster type name, I'd really like to be called something that should be on a poster. It should be a pop name.' So there was a form on the desk where I was sitting at the Factory and it had 'Name_____ Address_____ Telephone_____', so I was just fiddling with a pen and I wrote Billy on the line and then stopped. And I said 'Billy Name, that is a great pop name' and I said 'Andy, next time we do a poster, put Billy Name.' And he said 'Oh Billy, that's so cute, how'd you think of that?'

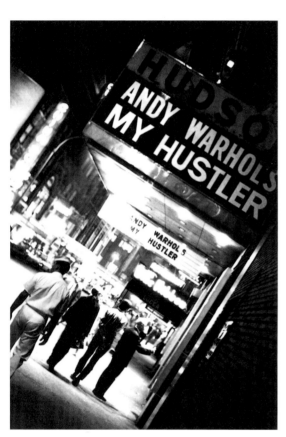

Hudson Theatre, Times Square, 1967

The Second Factory, 33 Union Square West. 1968

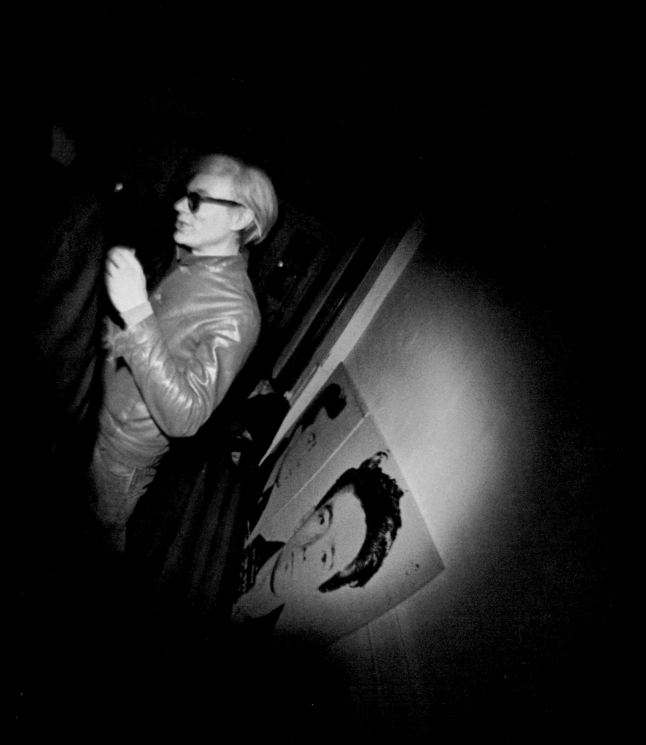

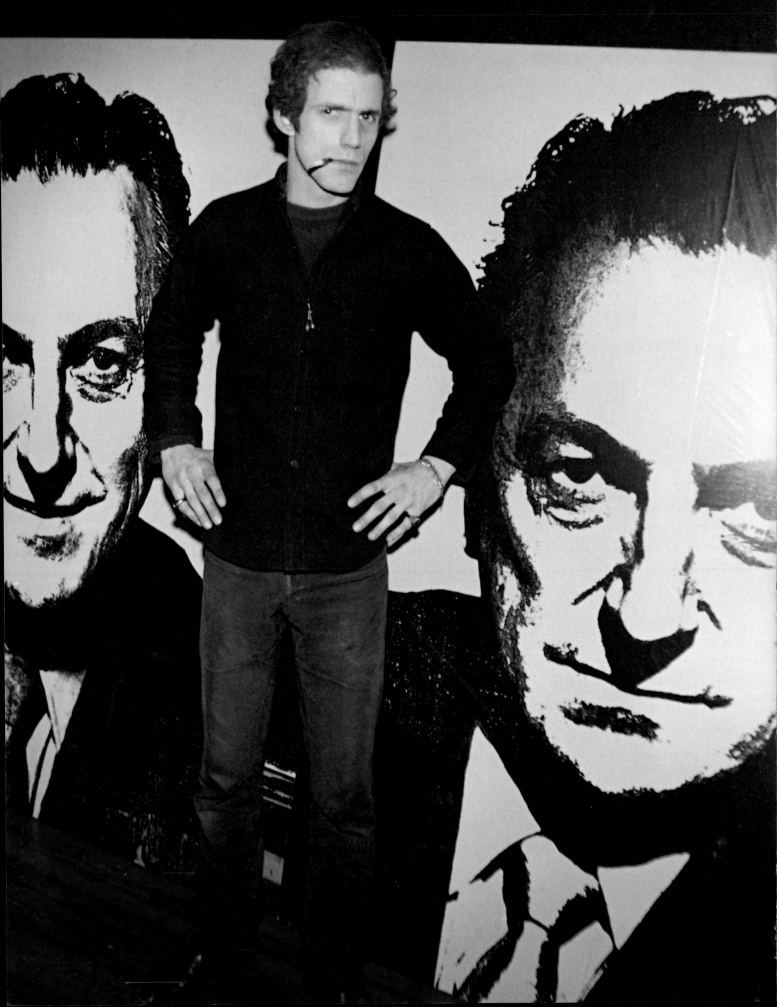

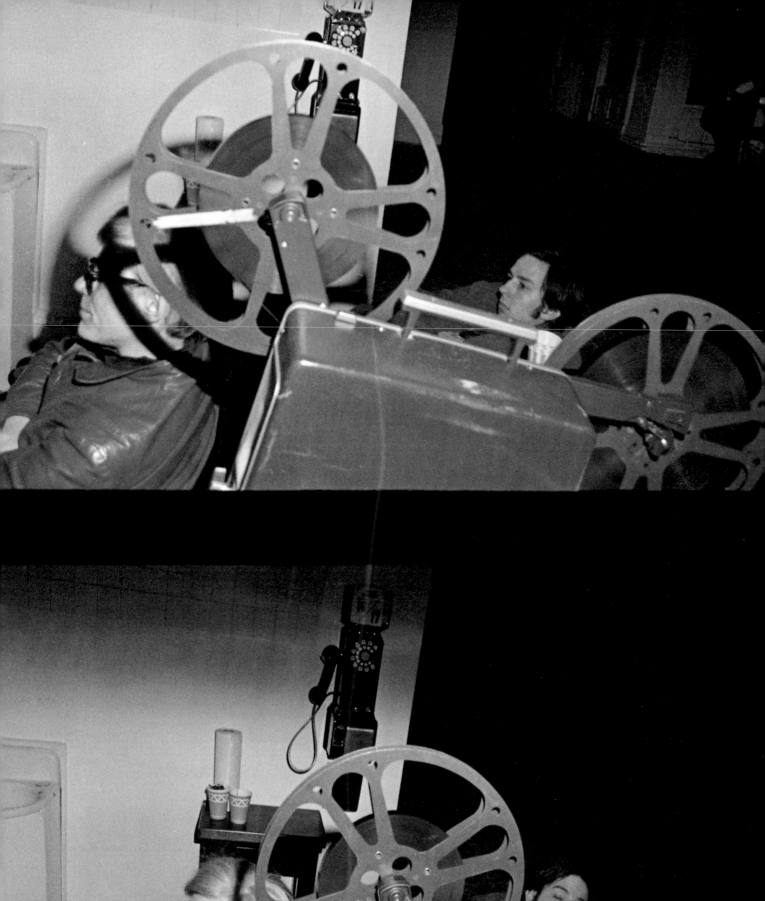

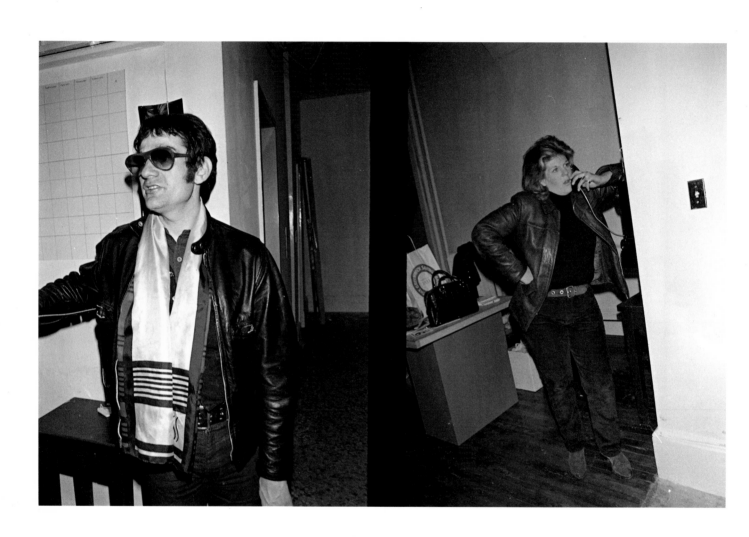

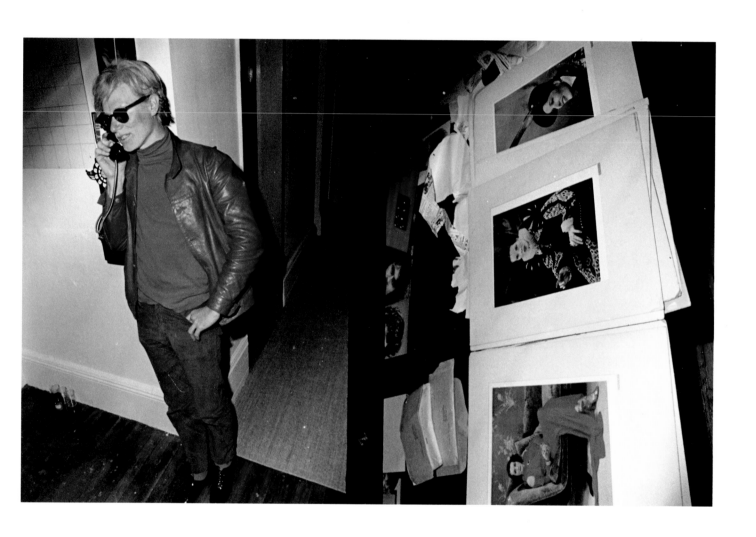

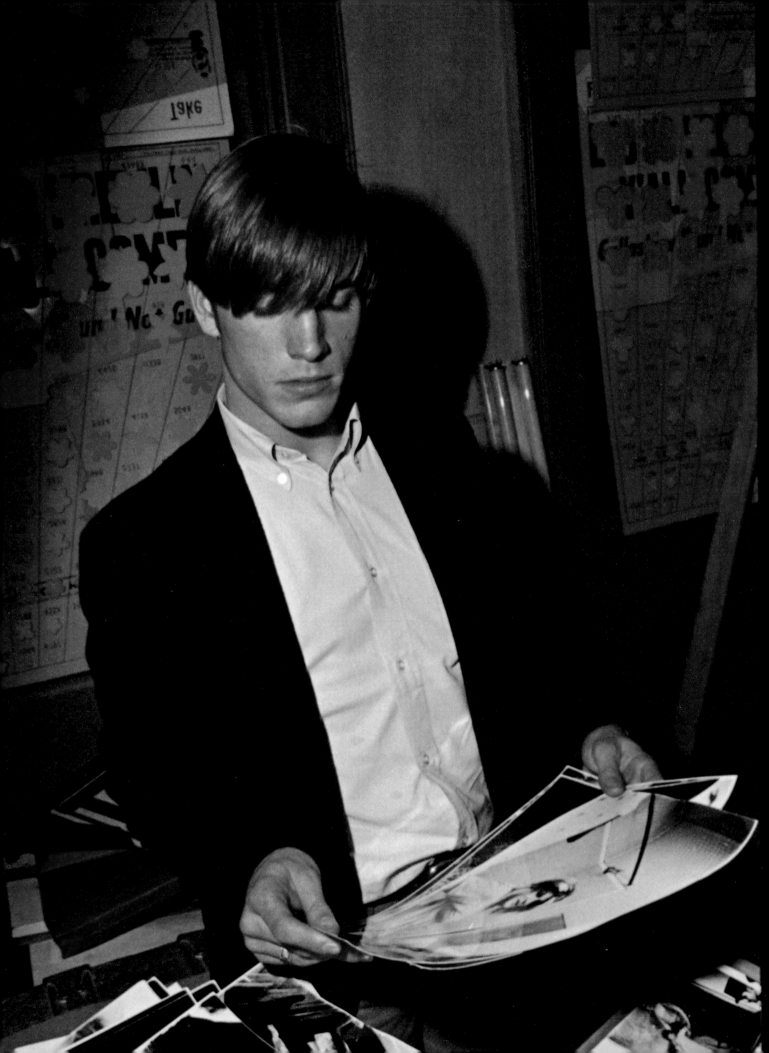

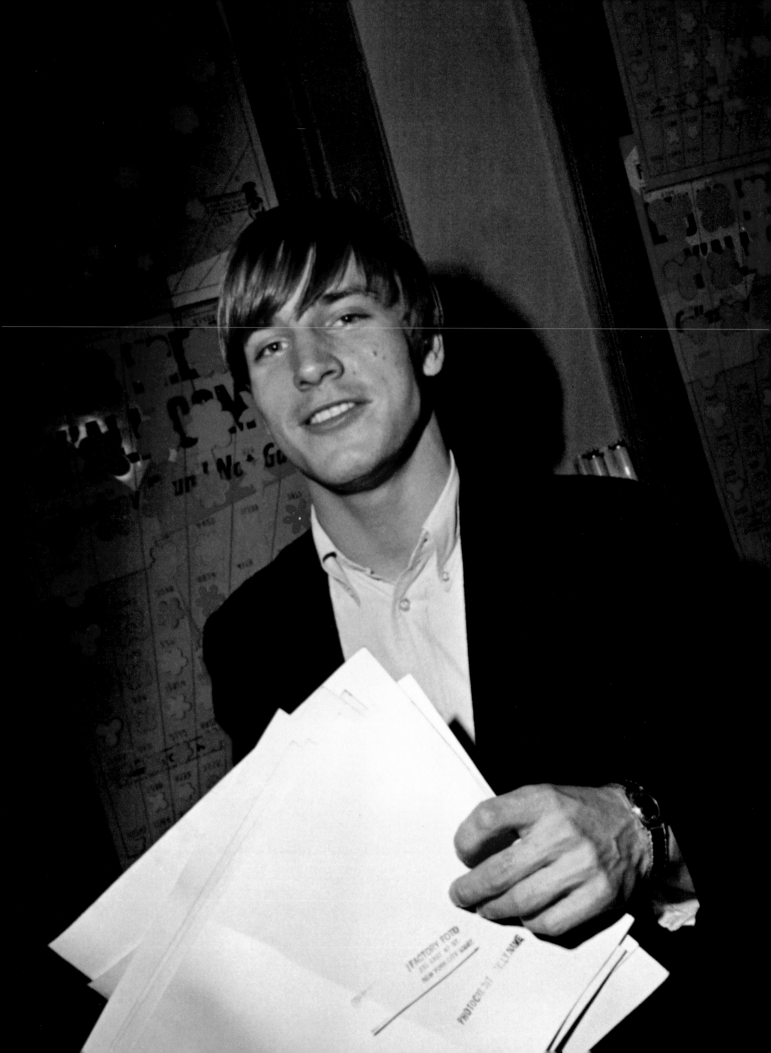

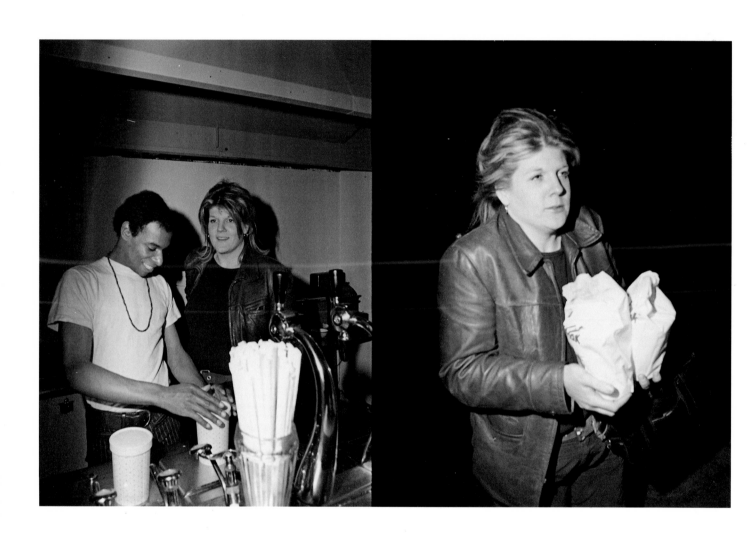

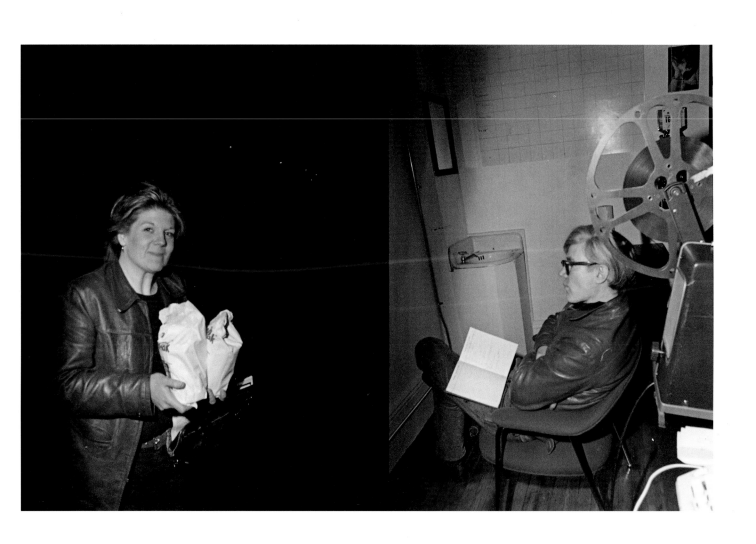

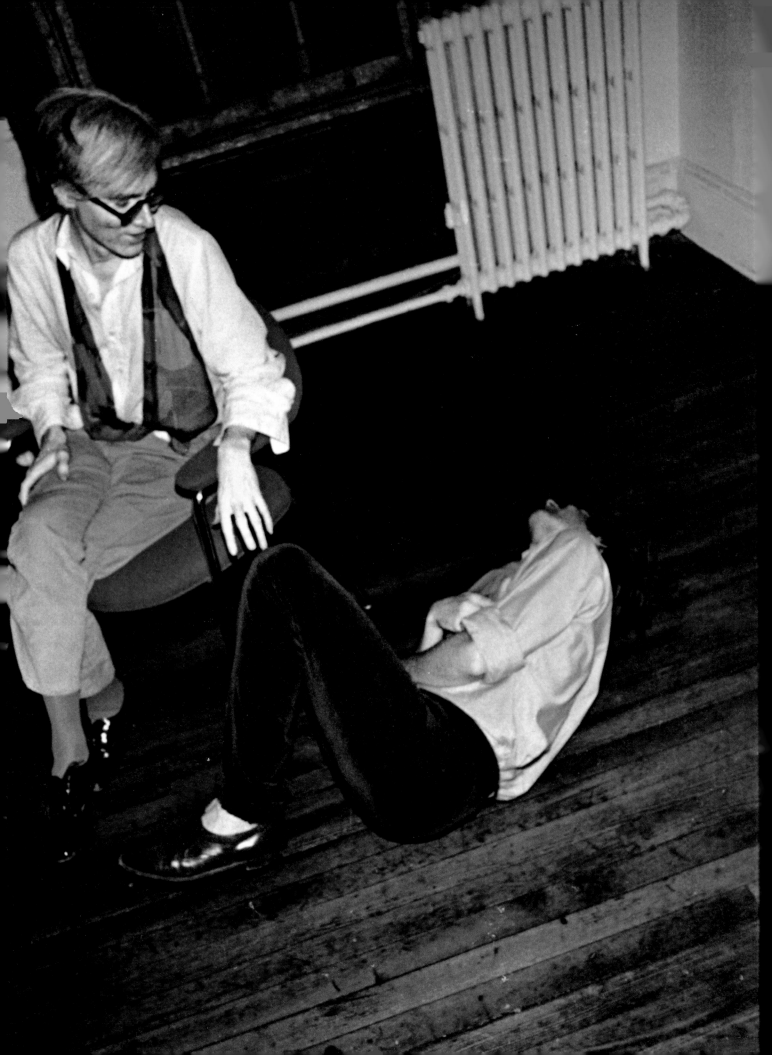

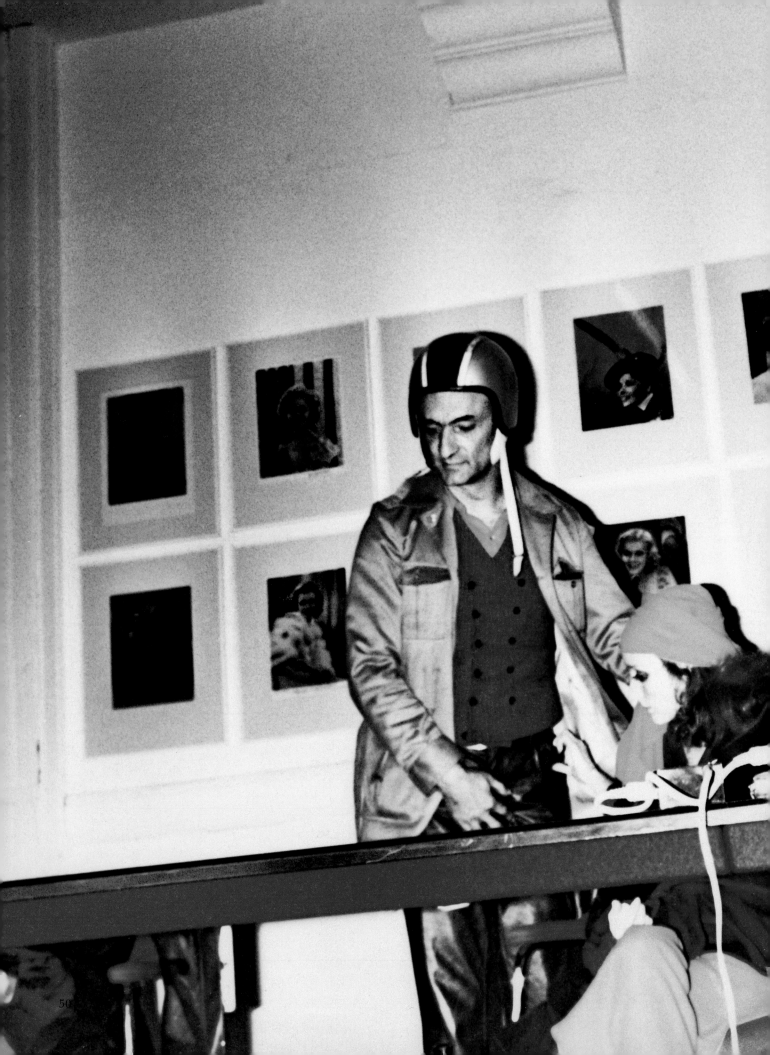

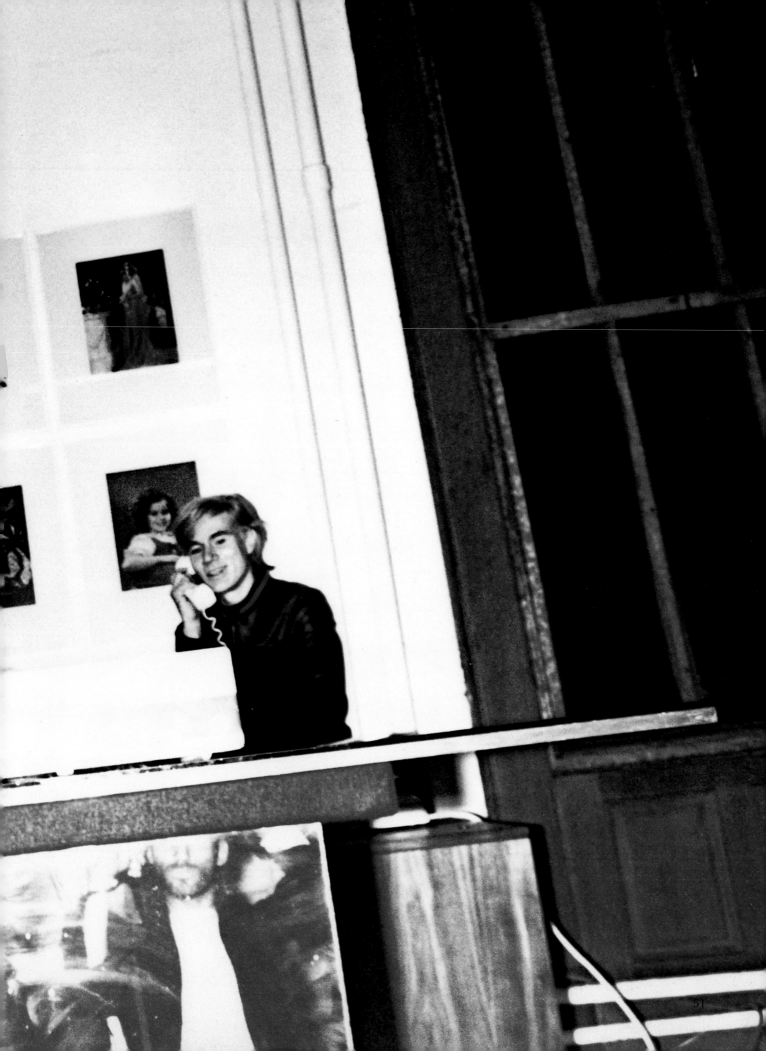

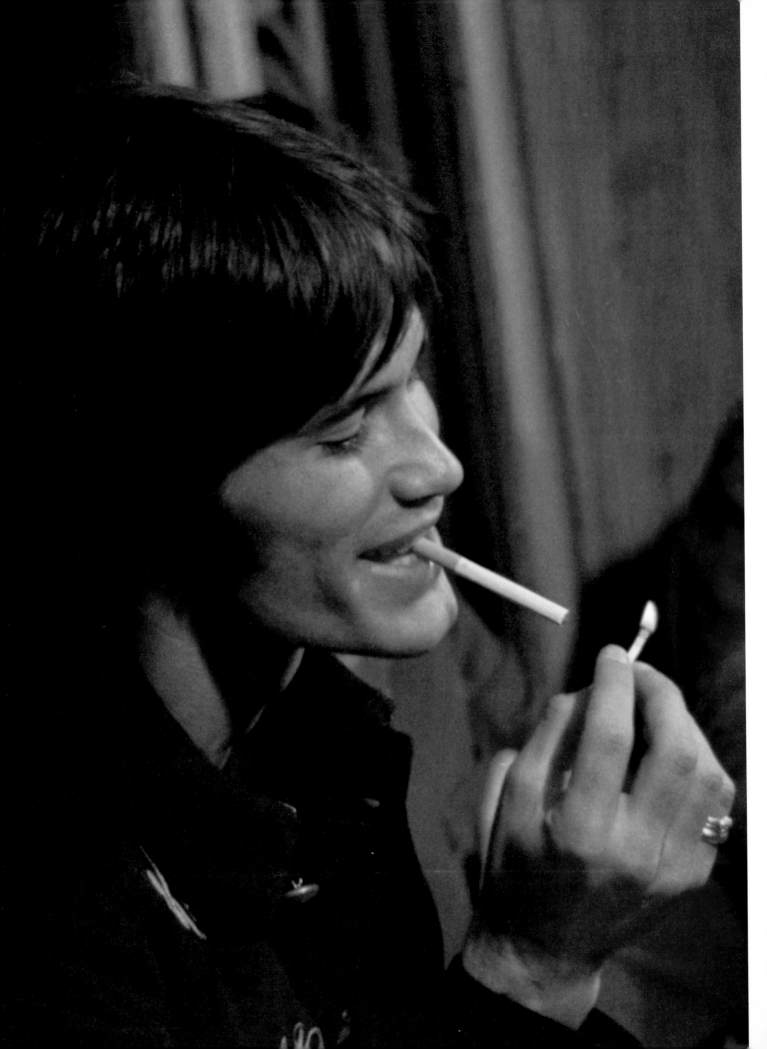

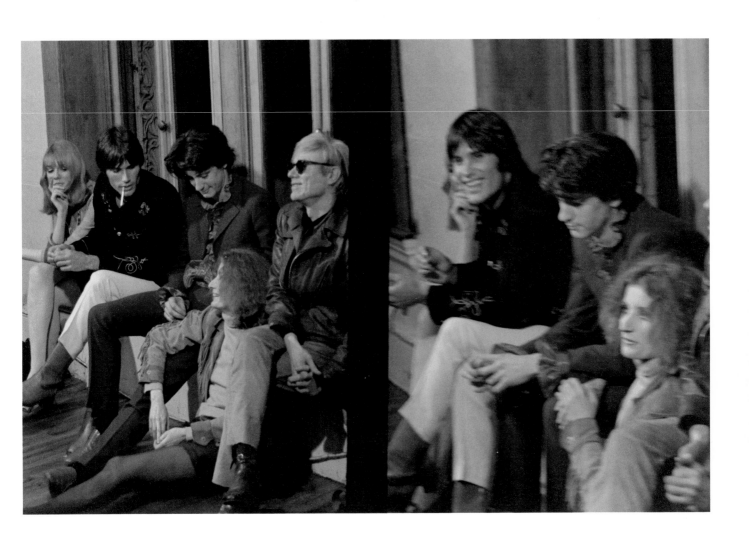

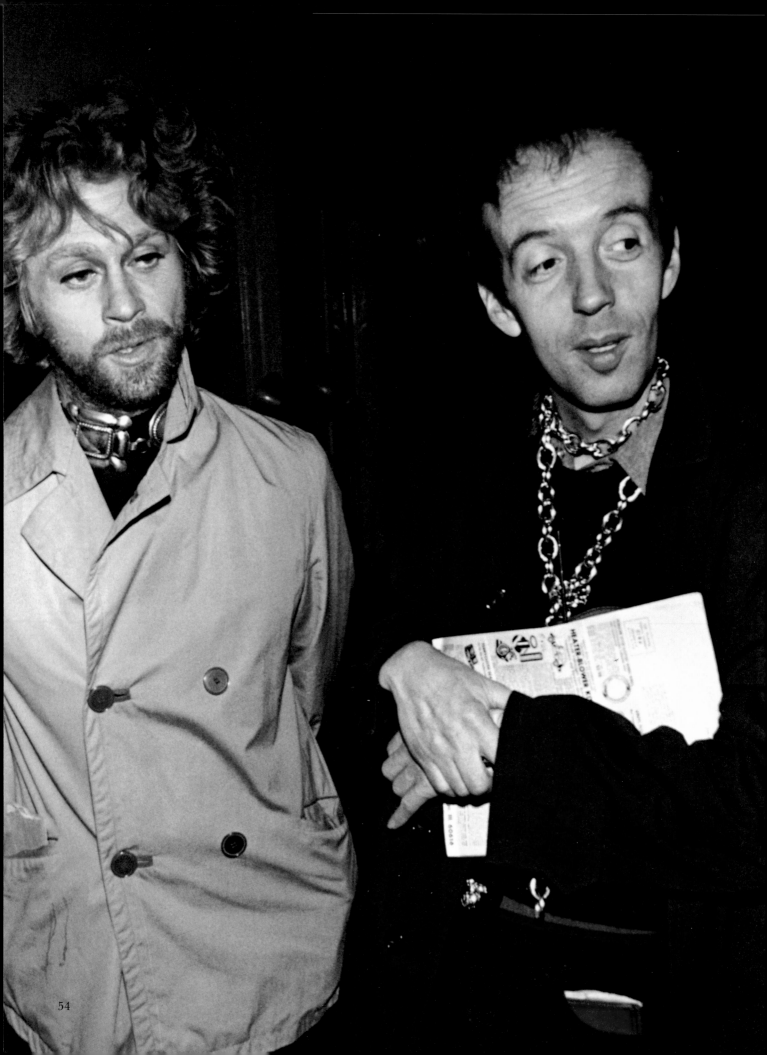

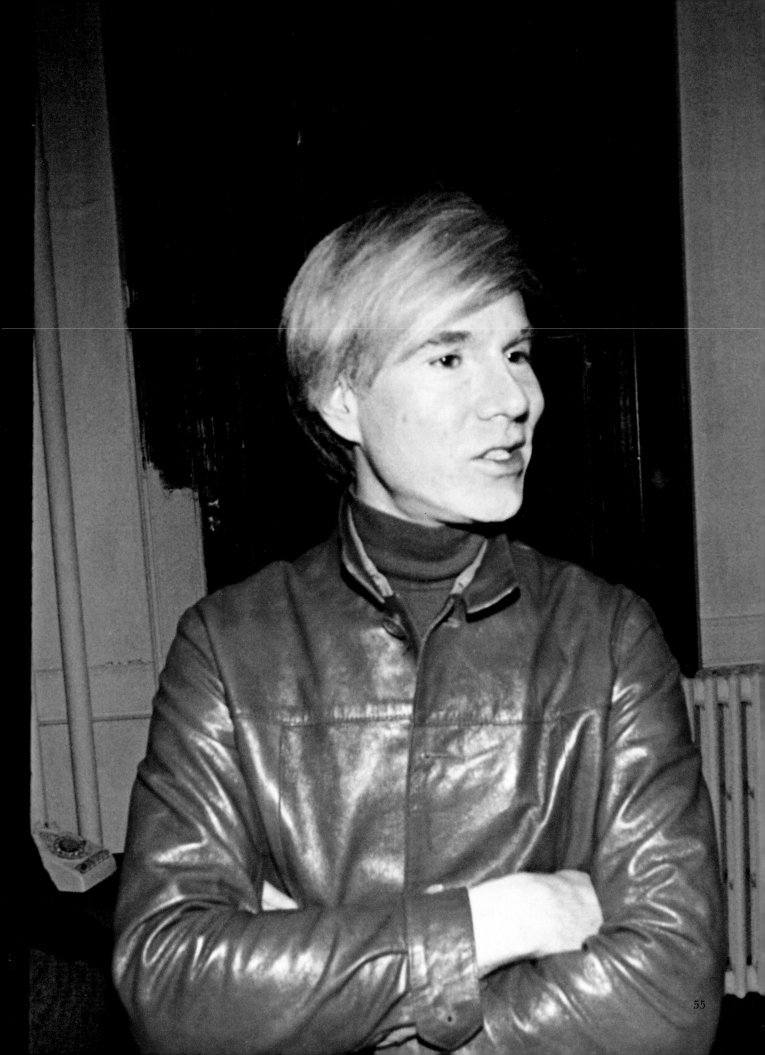

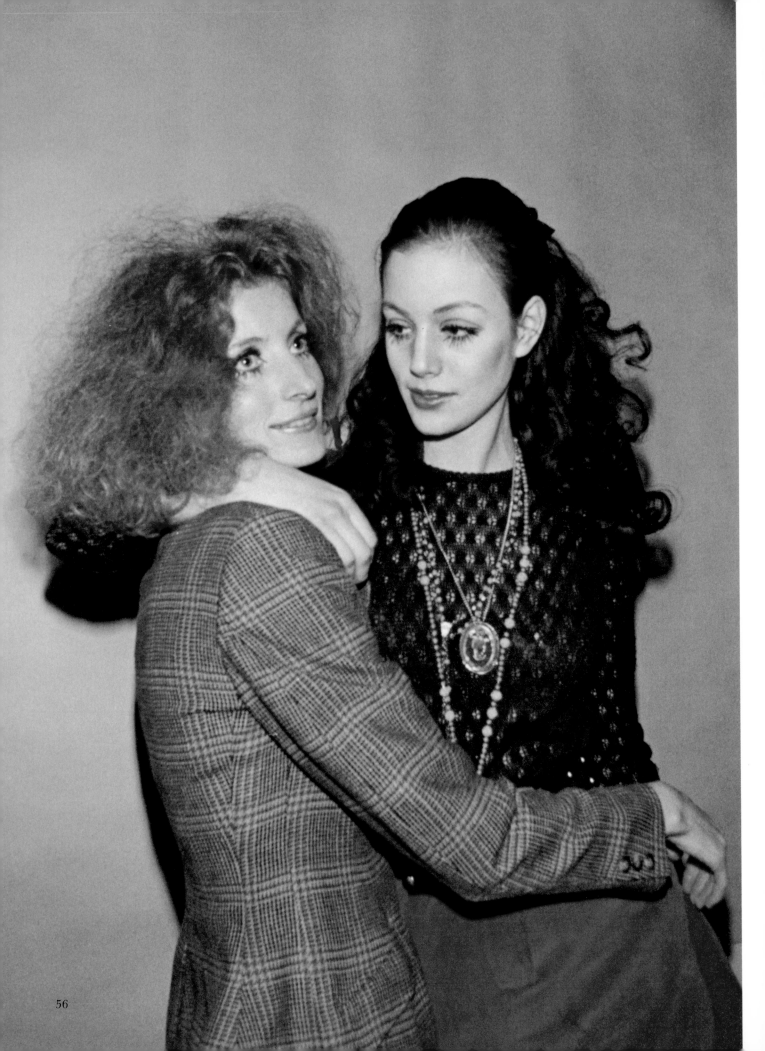

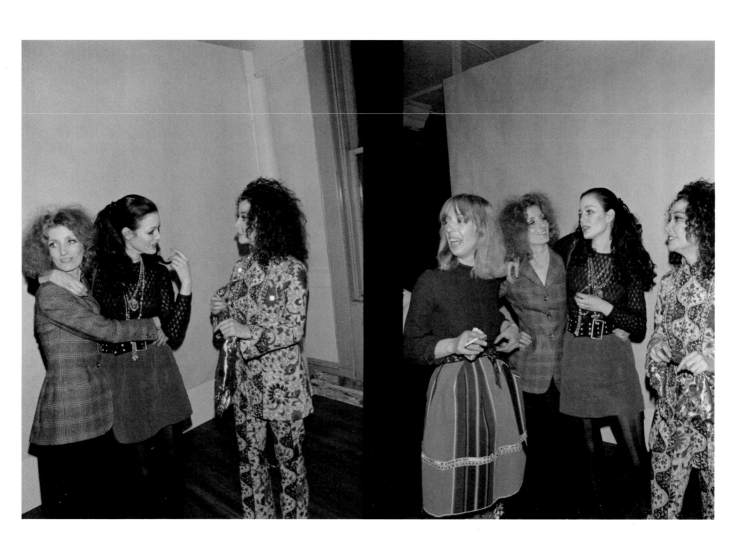

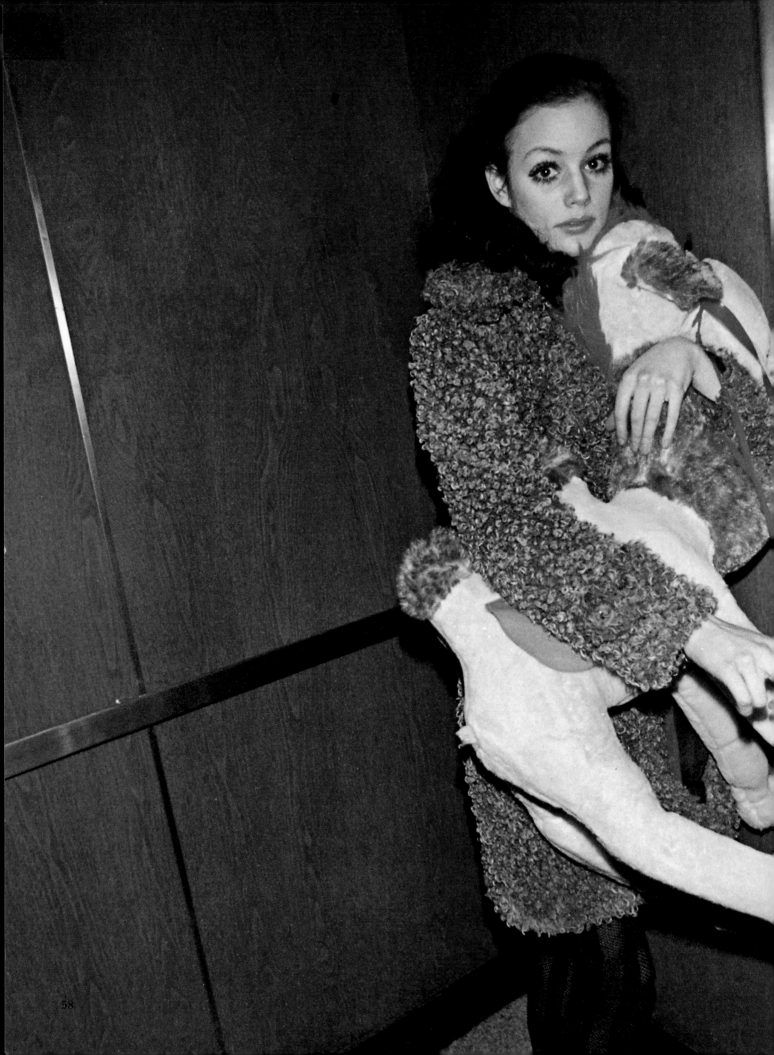

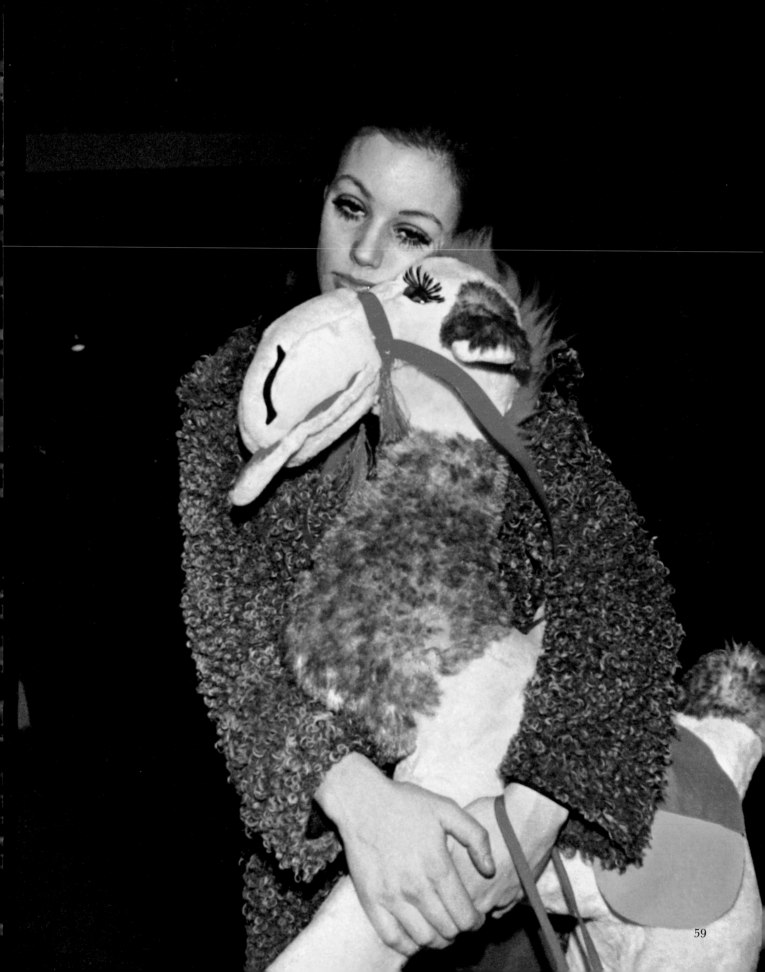

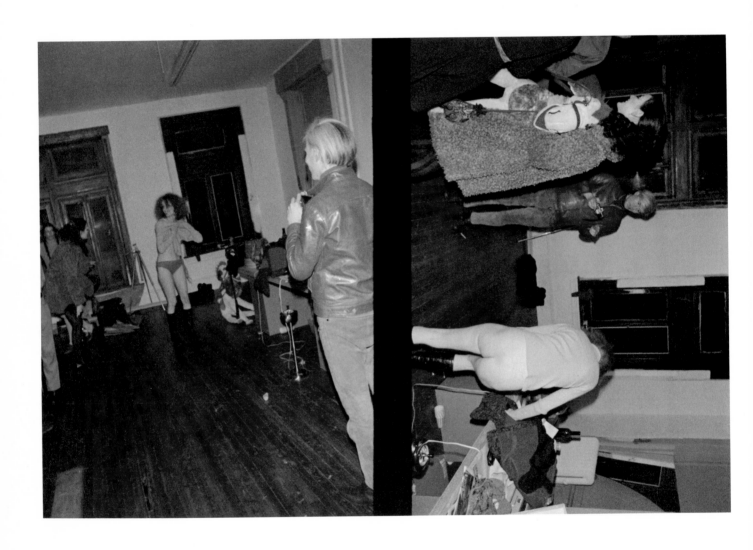

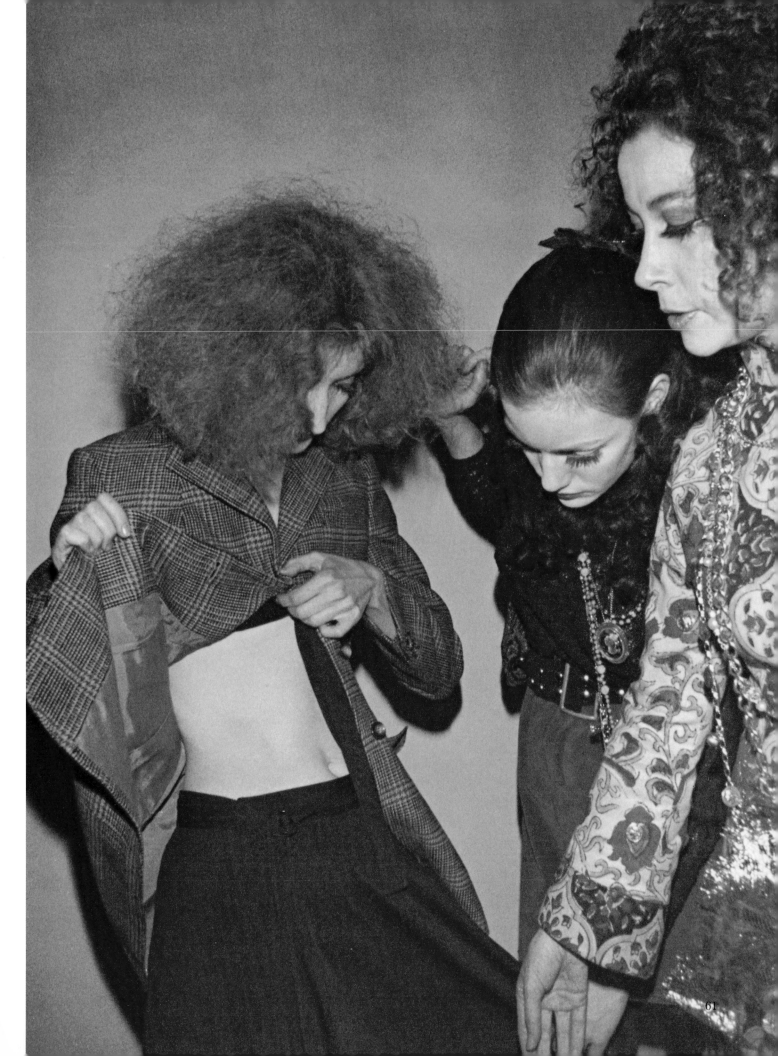

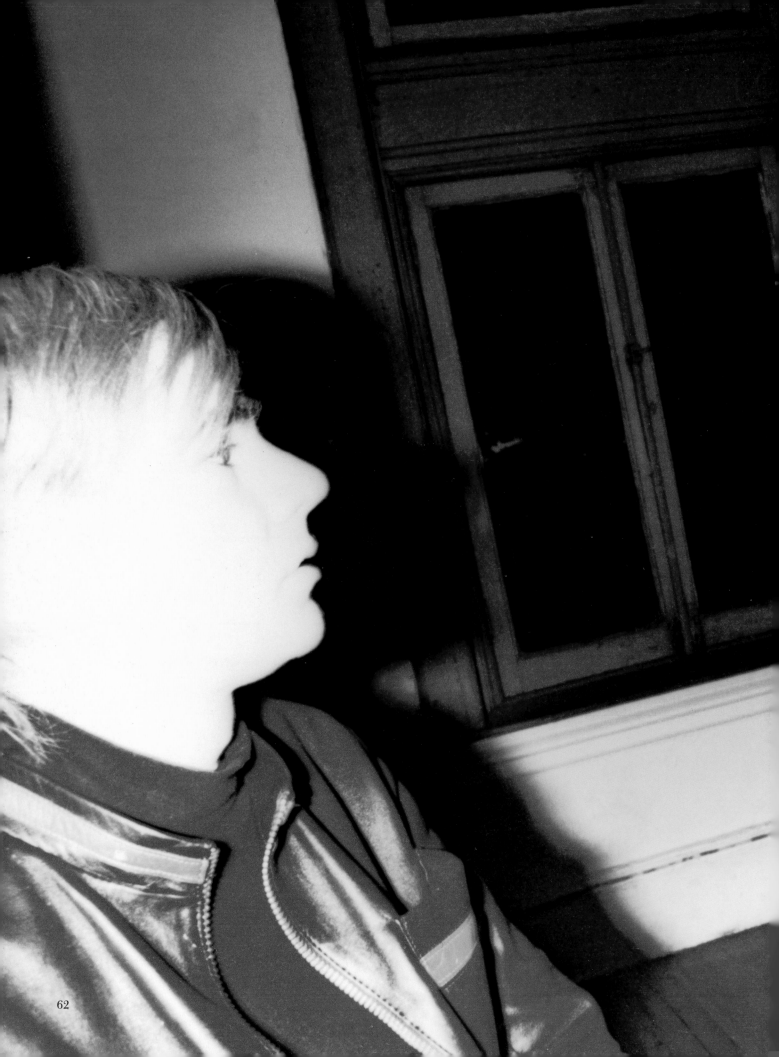

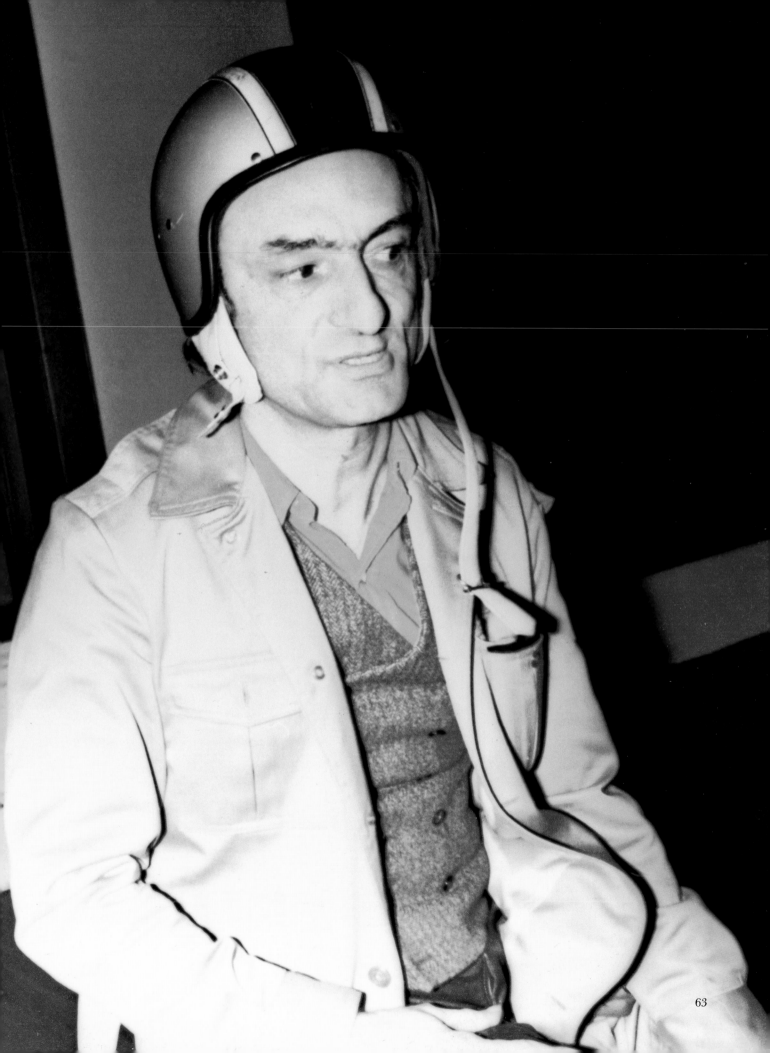

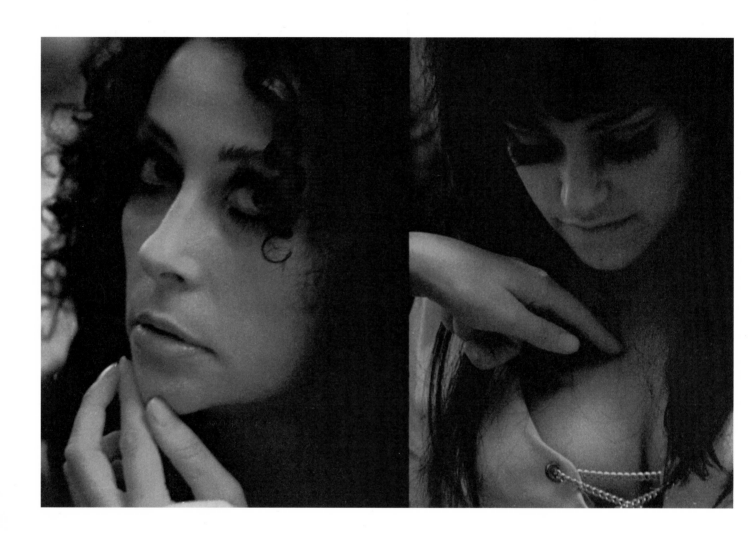

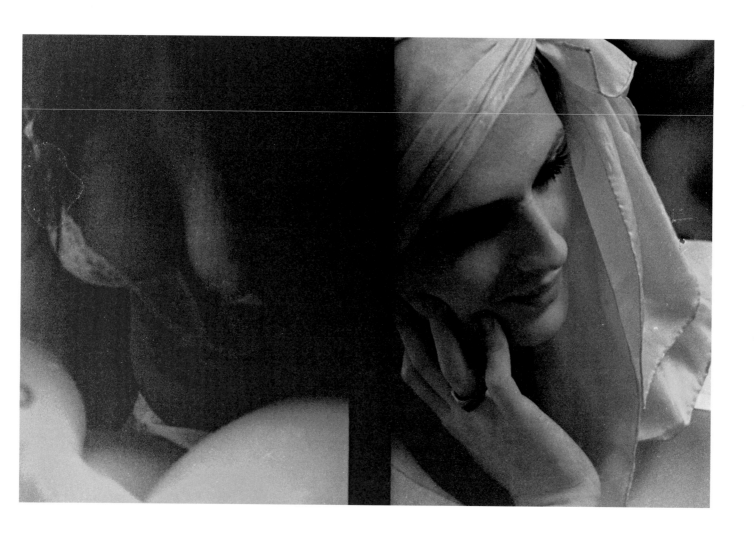

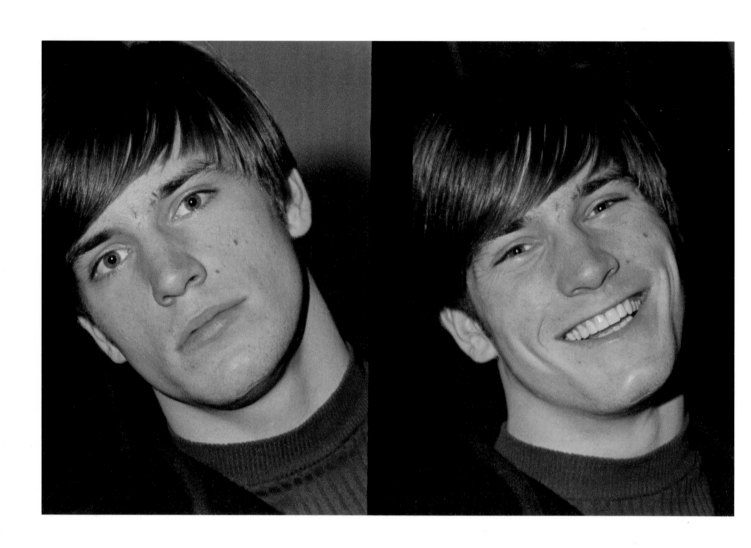

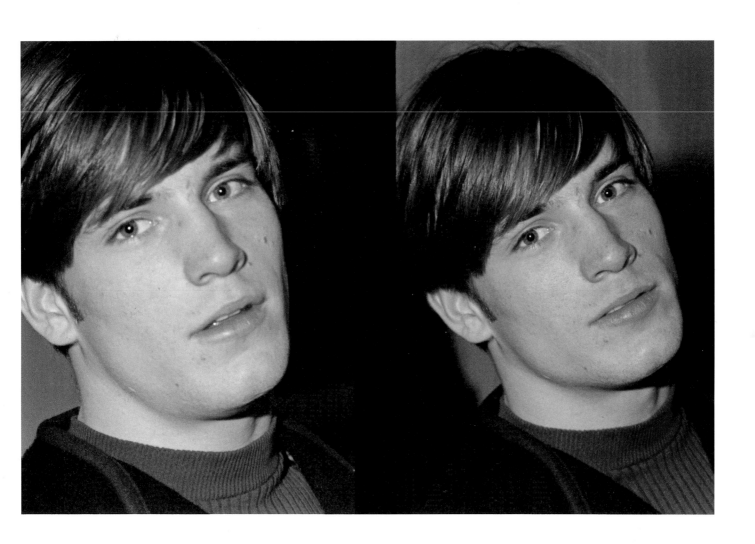

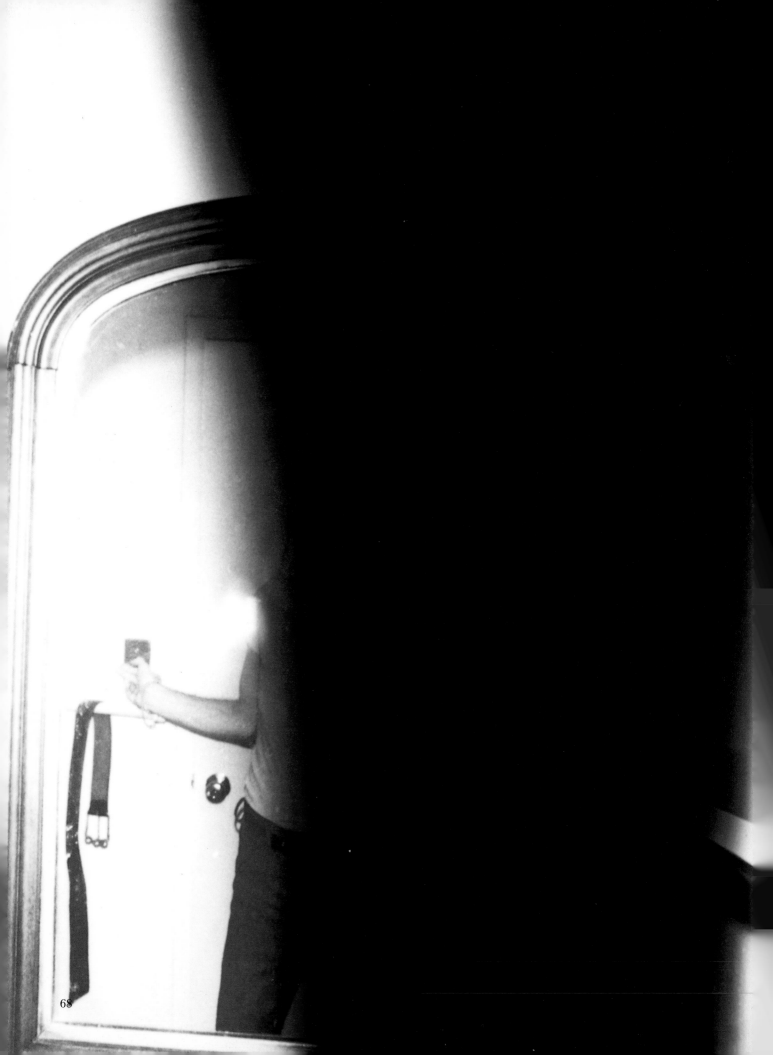

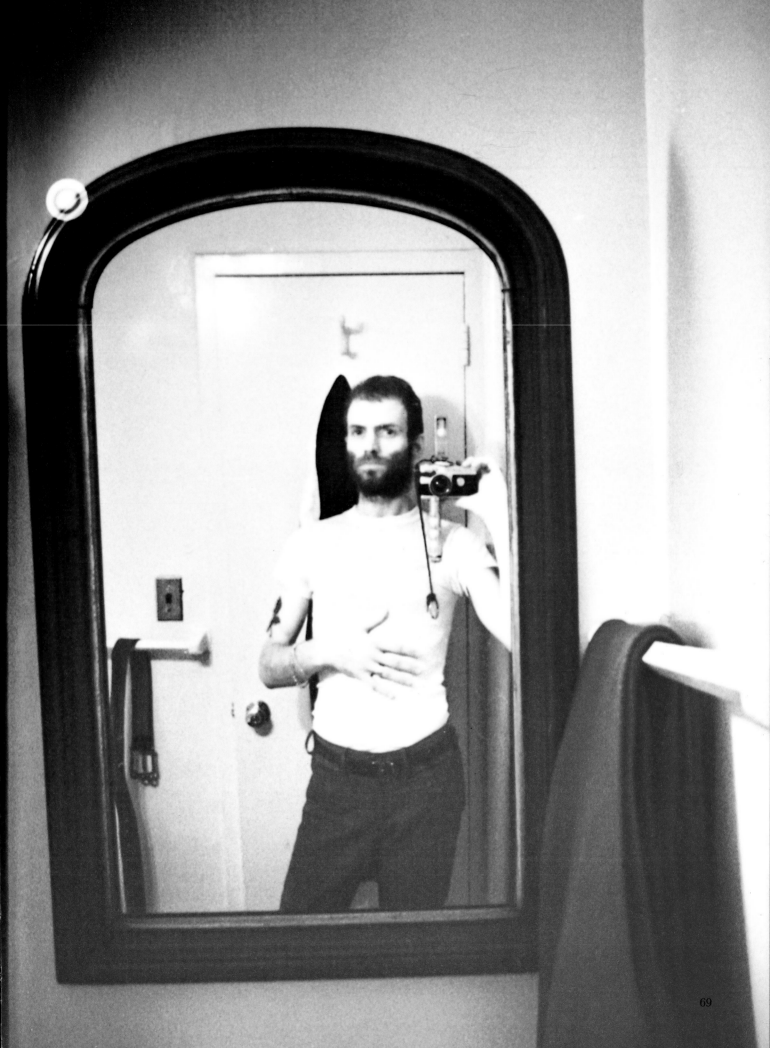

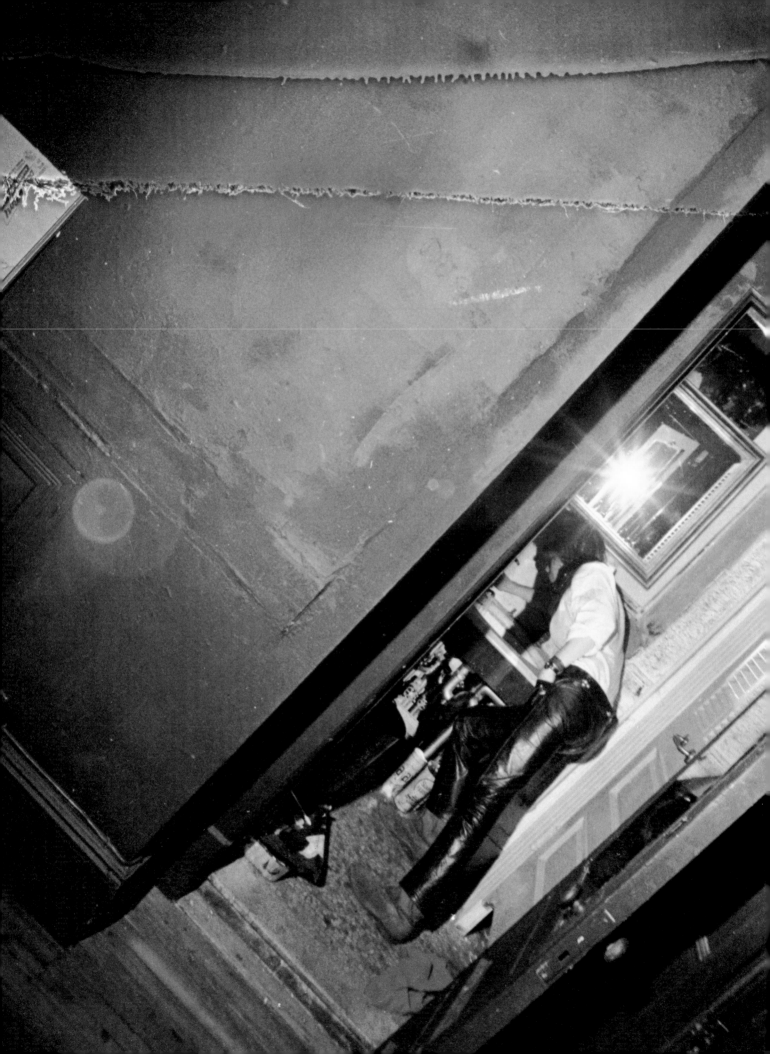

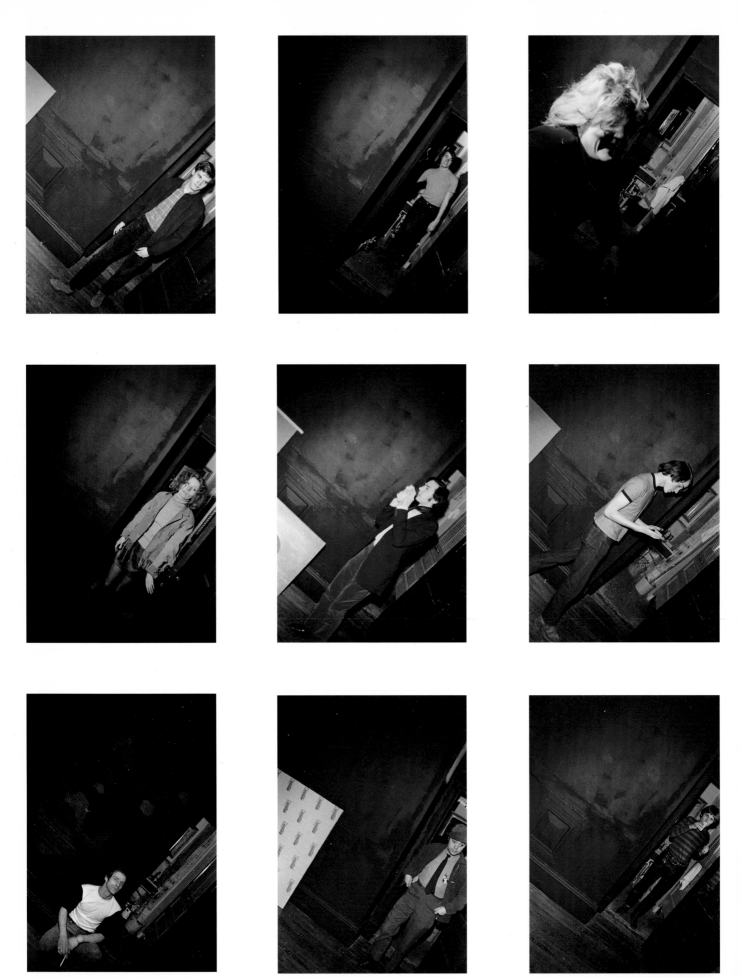

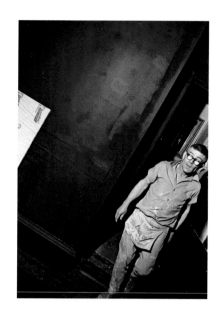 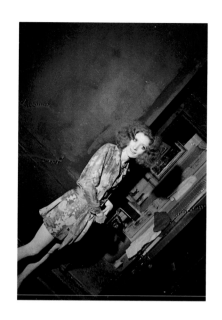

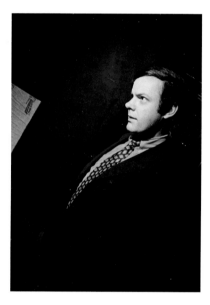 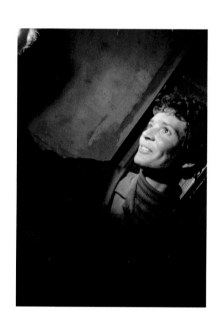 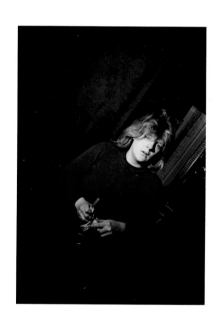

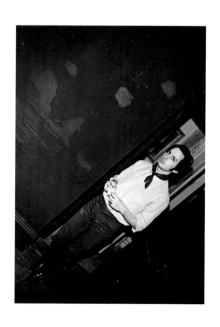 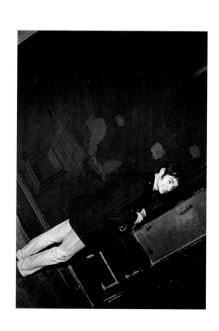 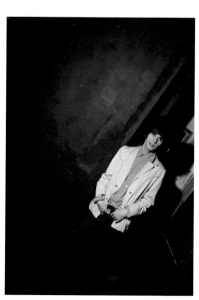

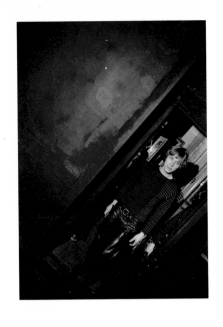 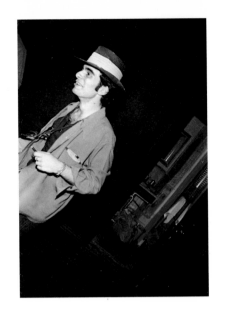 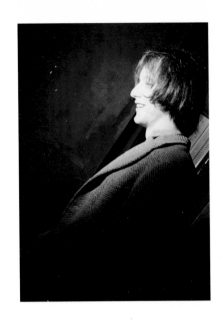

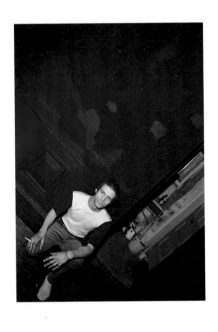 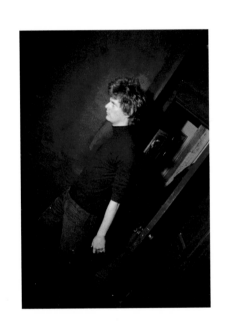 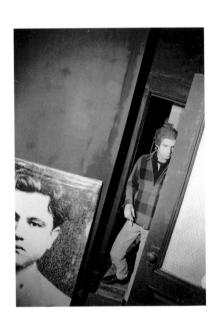

 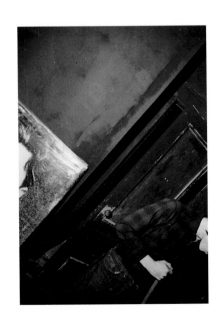 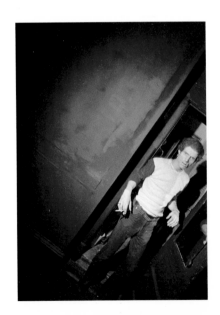

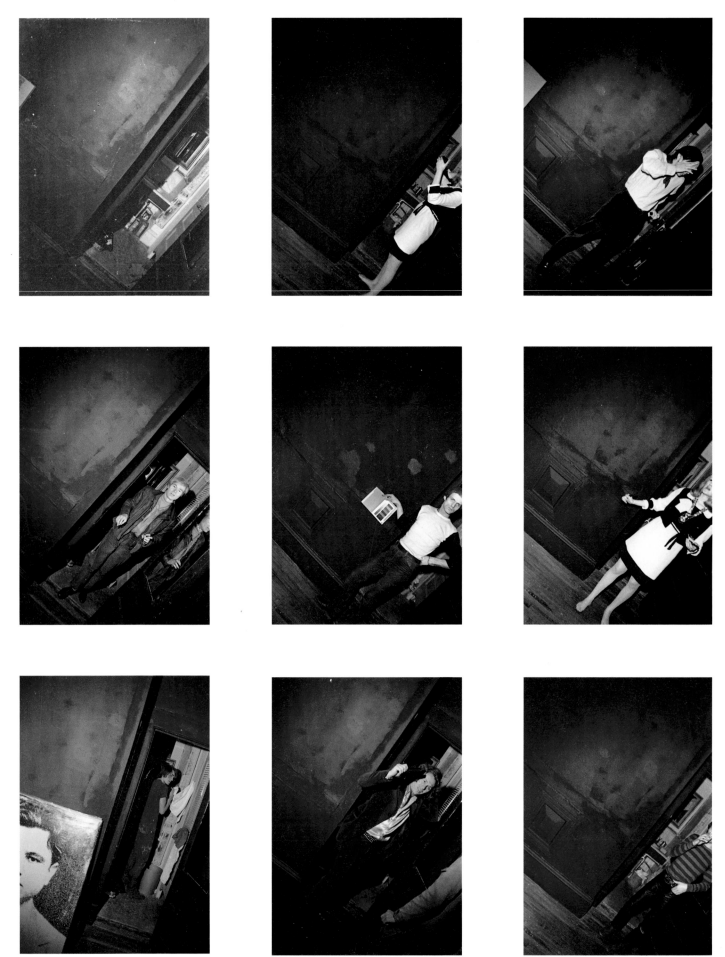

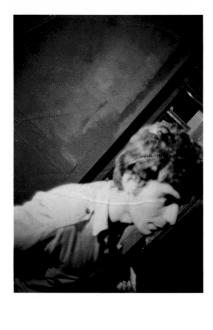 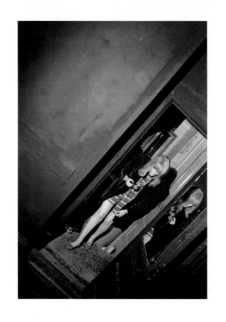 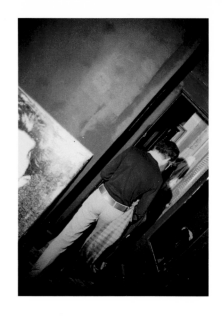

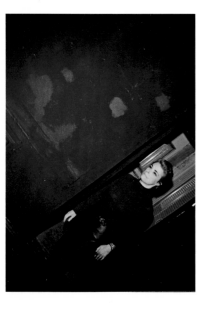 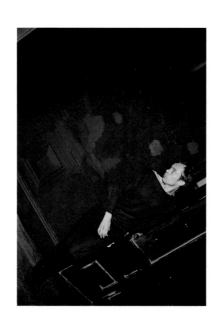 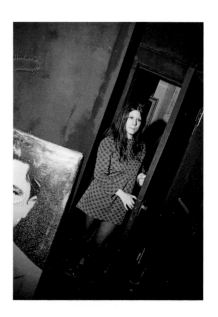

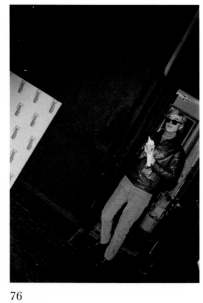 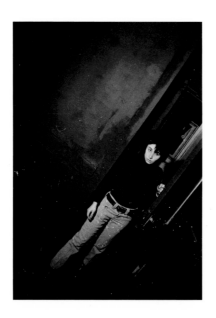 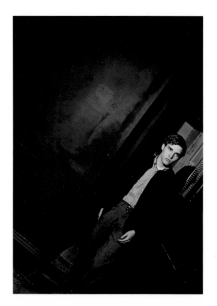

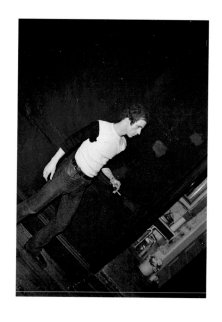
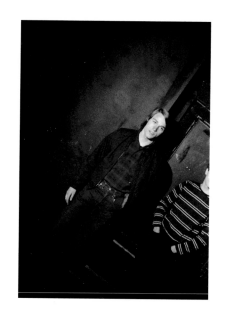
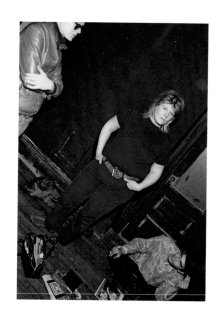
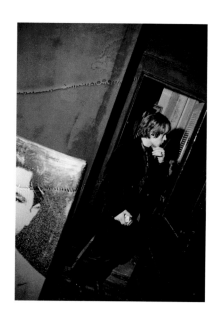
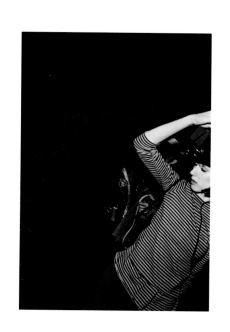
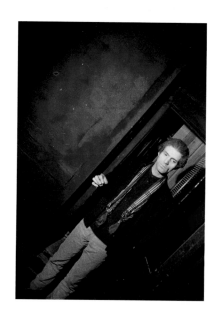
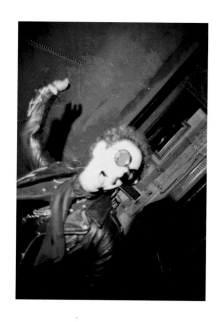
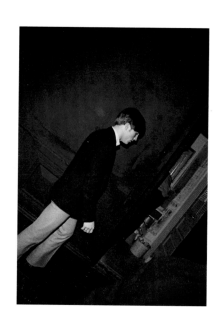
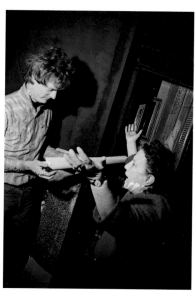

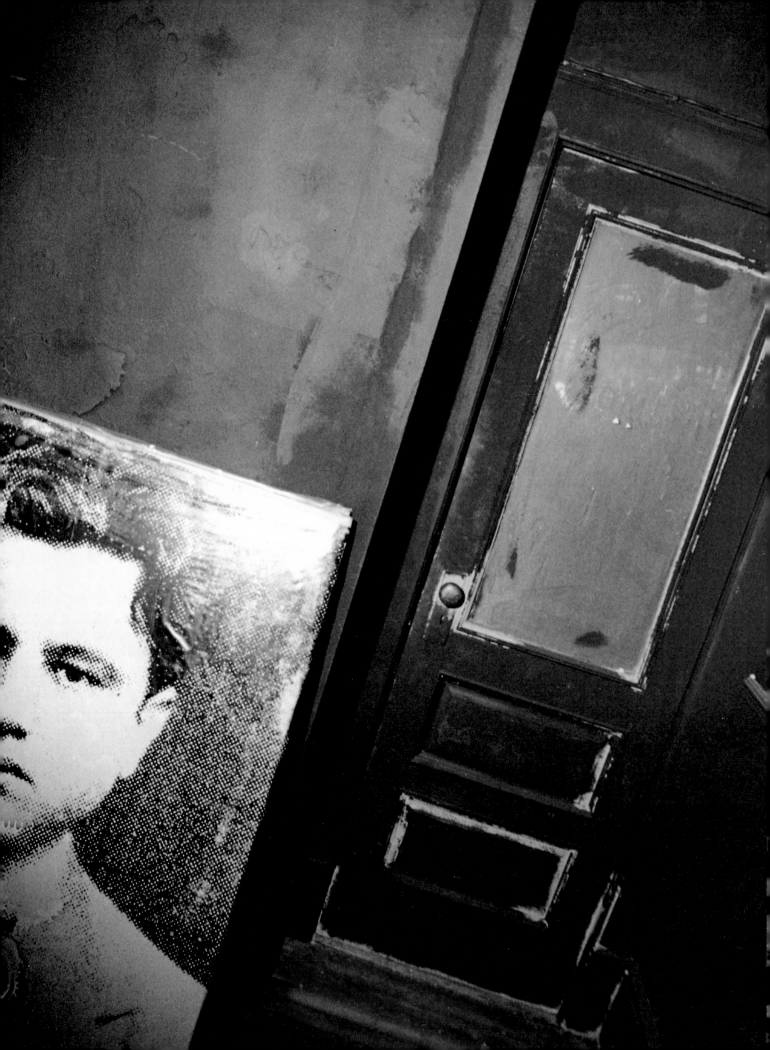

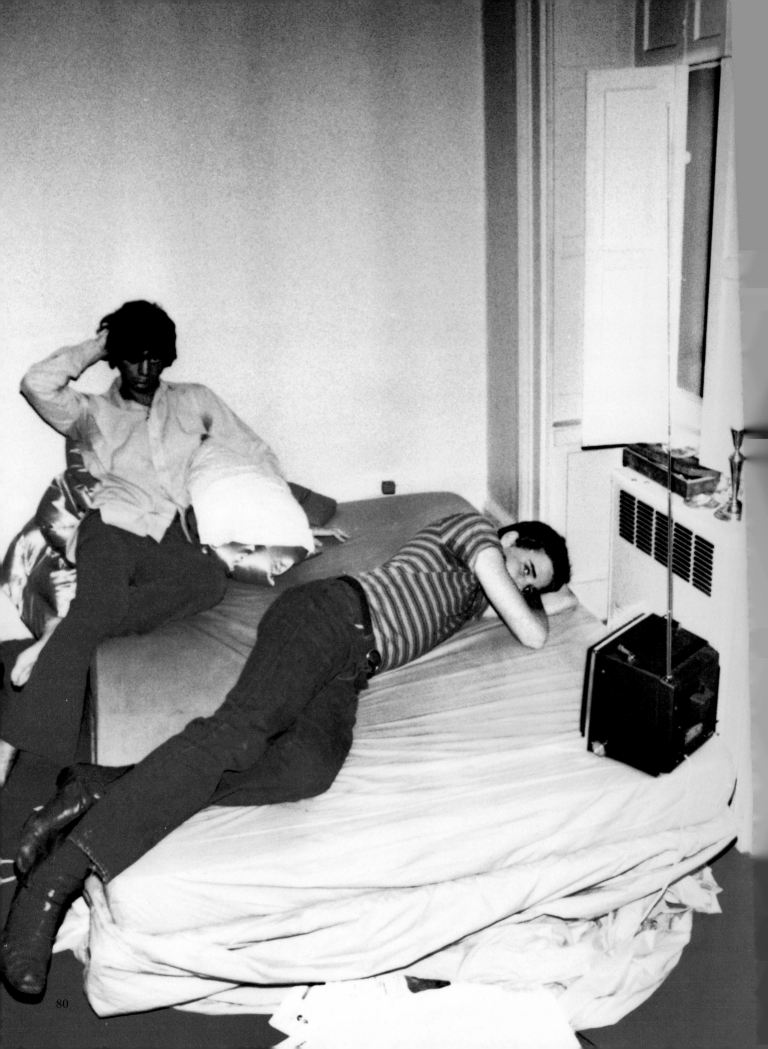

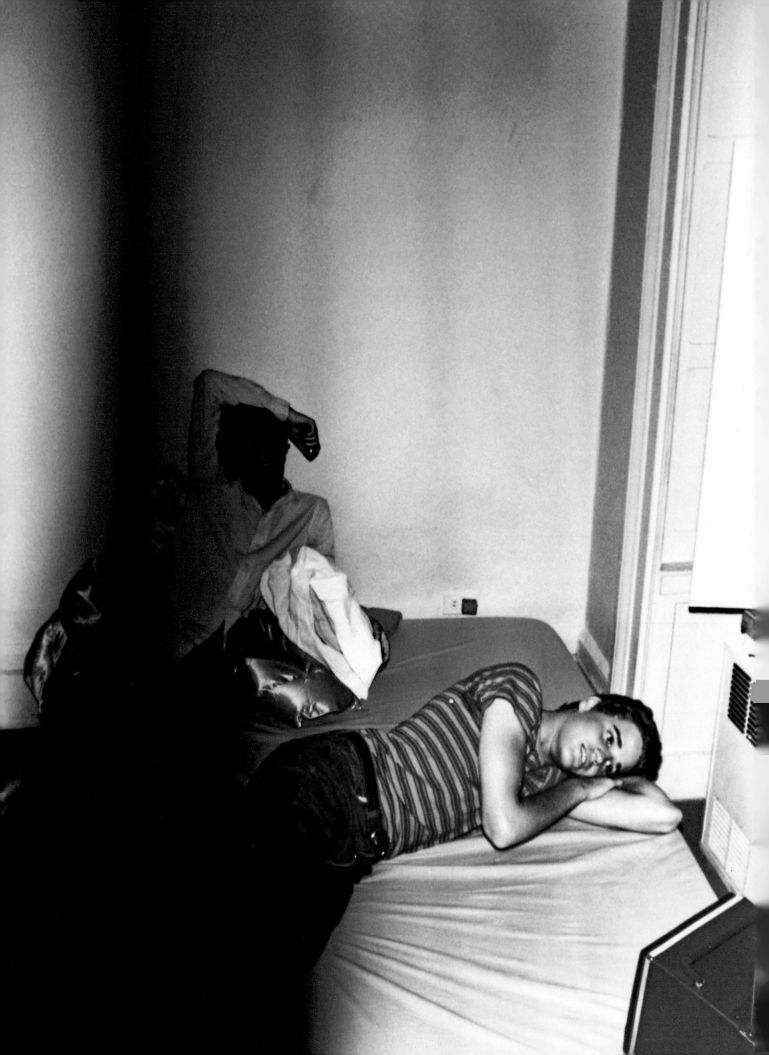

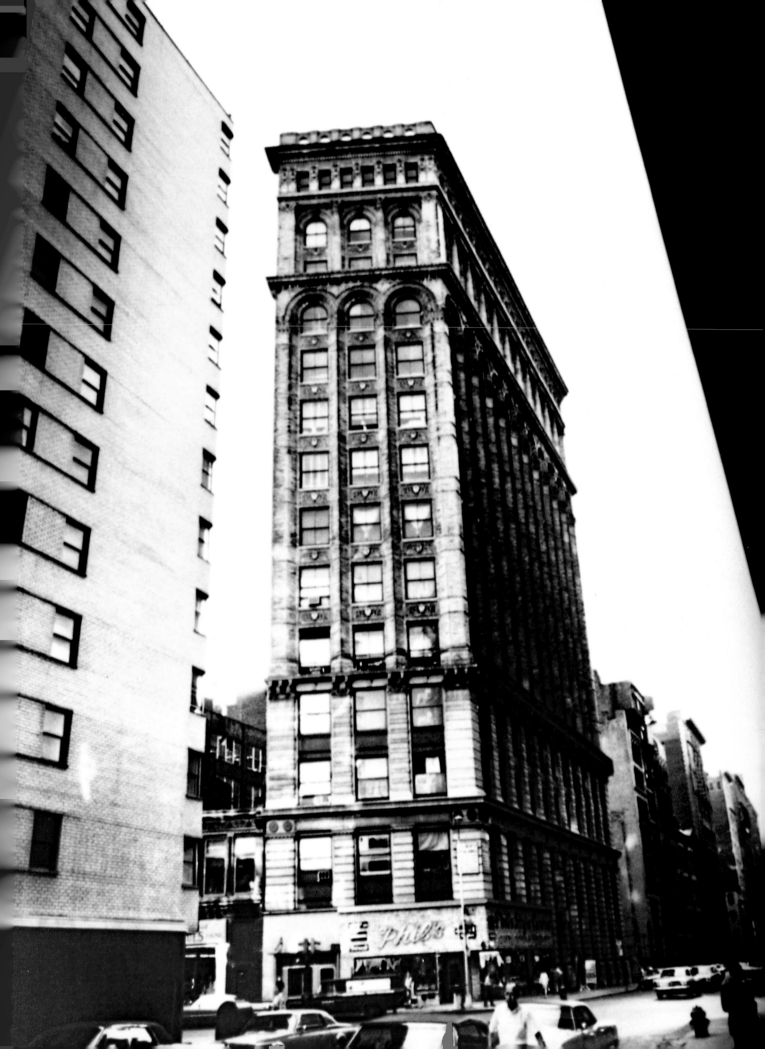

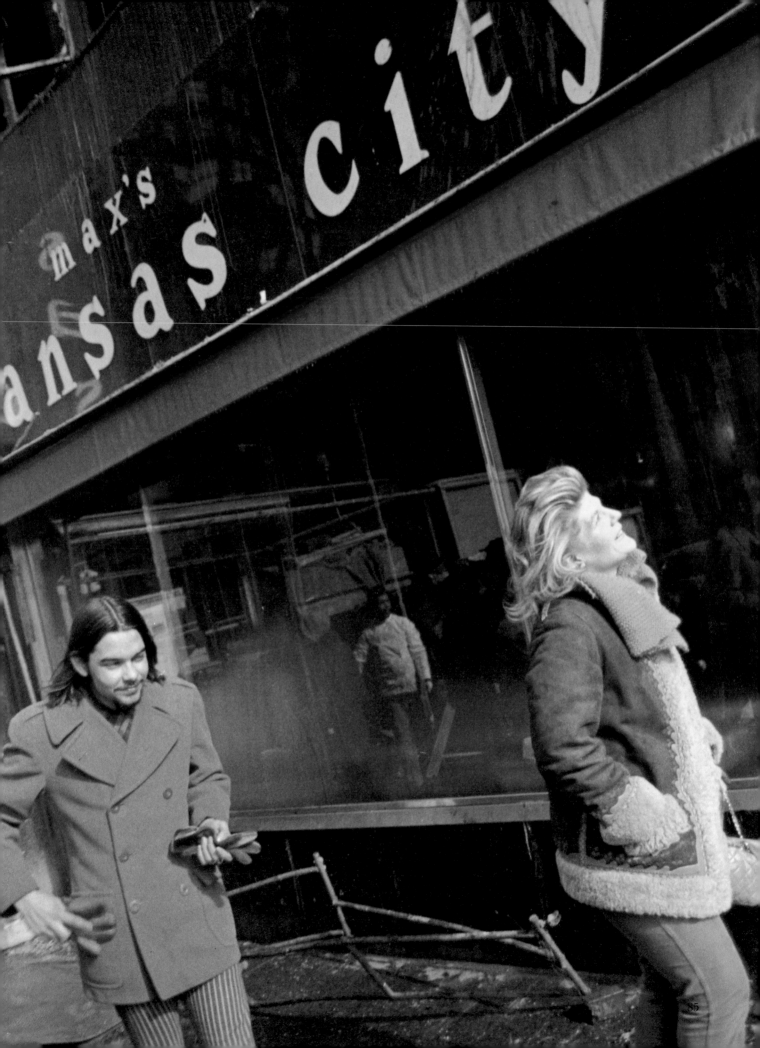

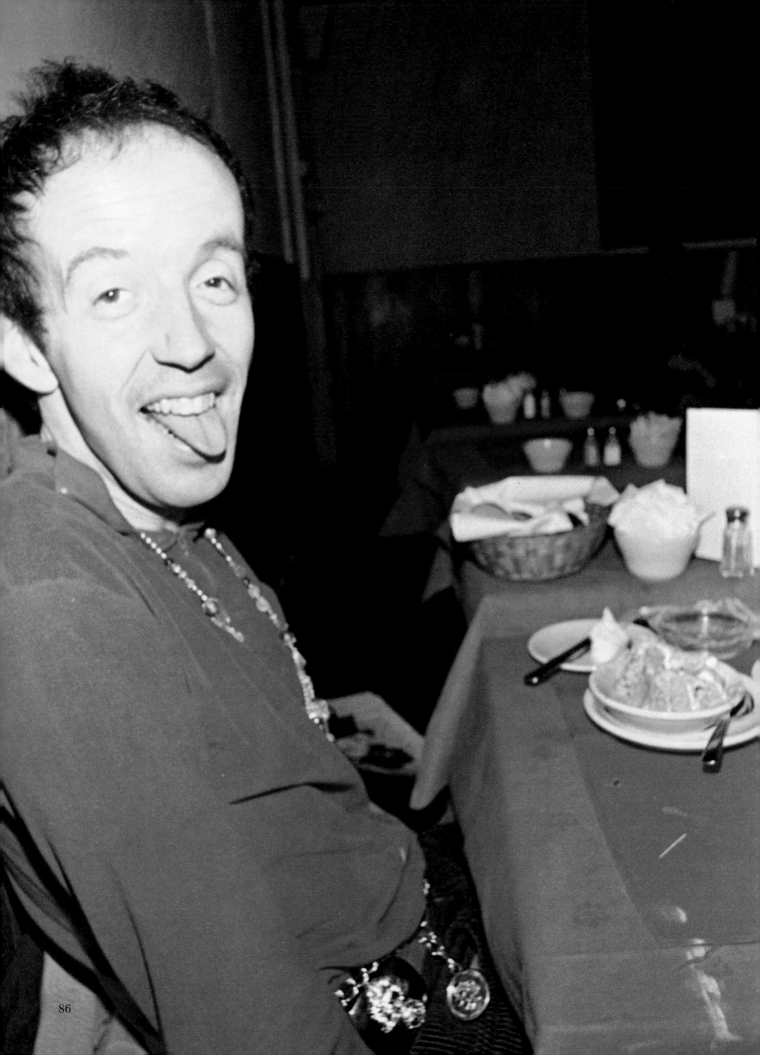

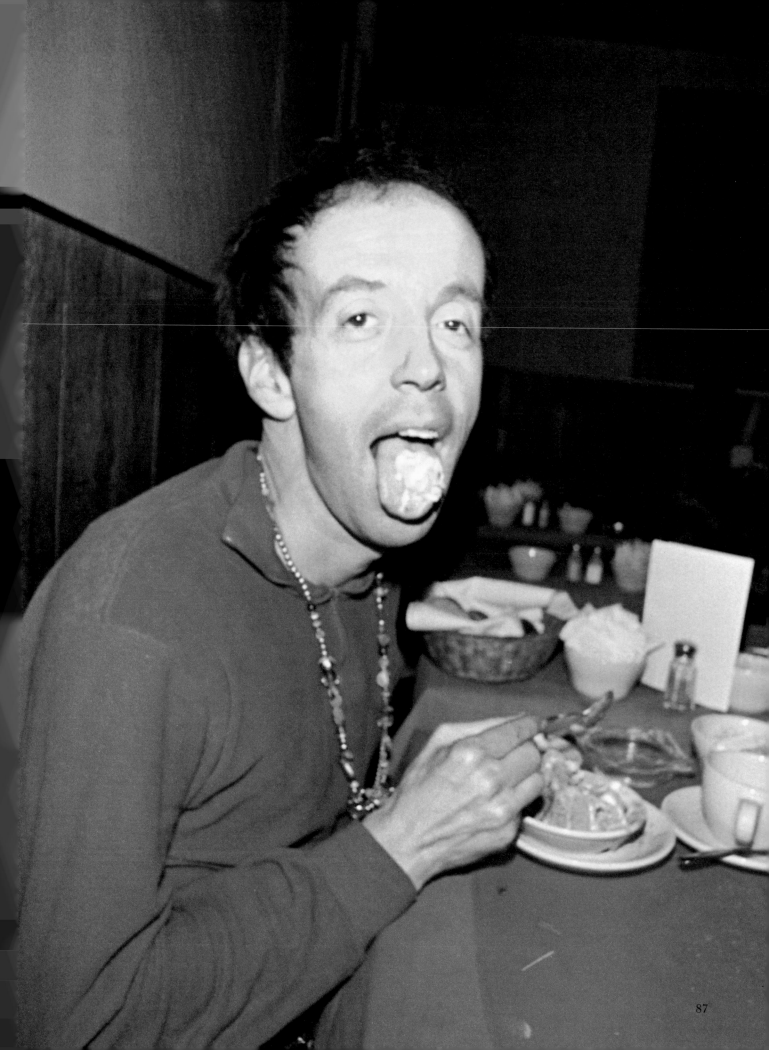

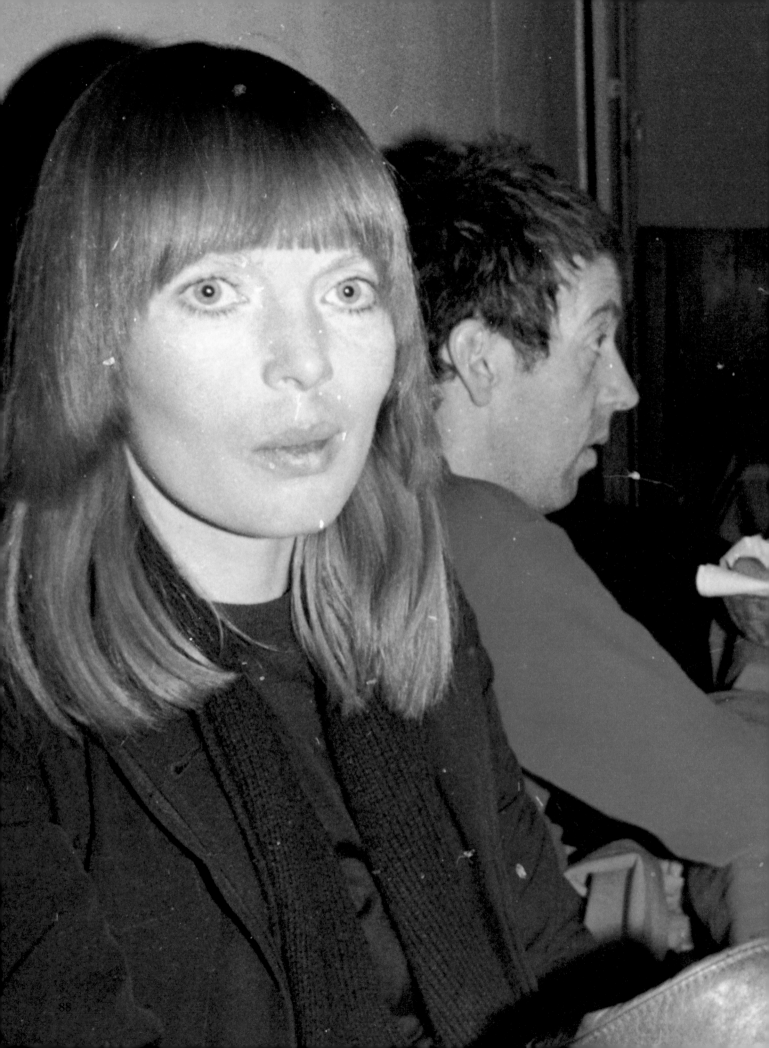

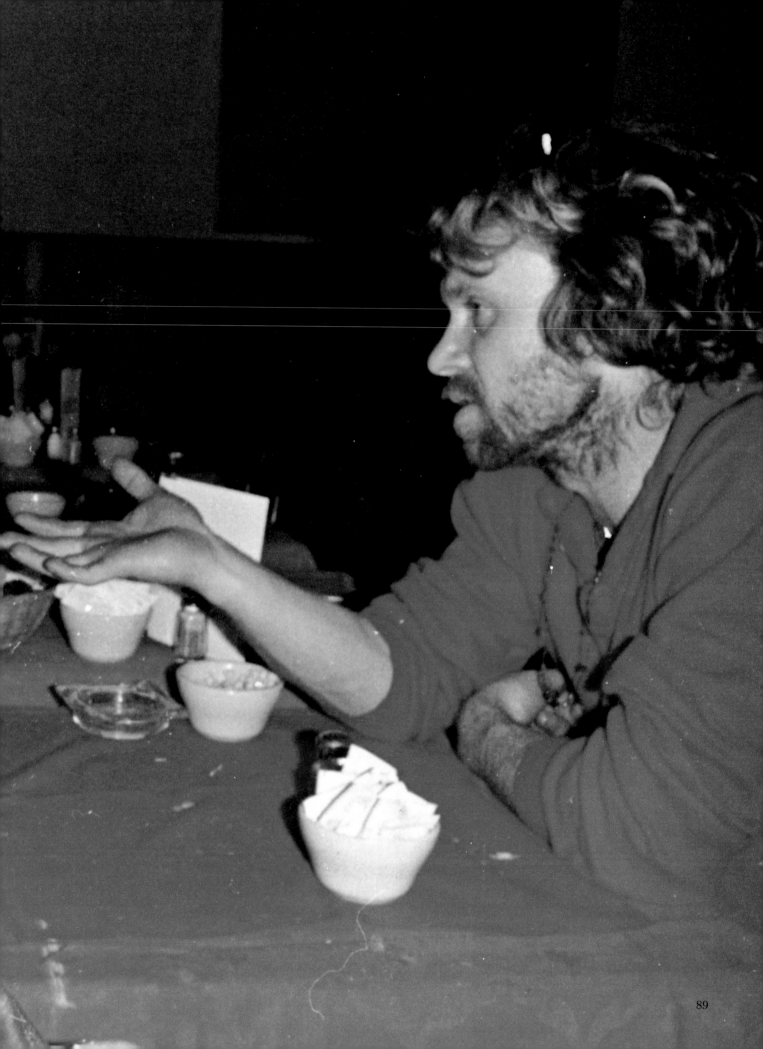

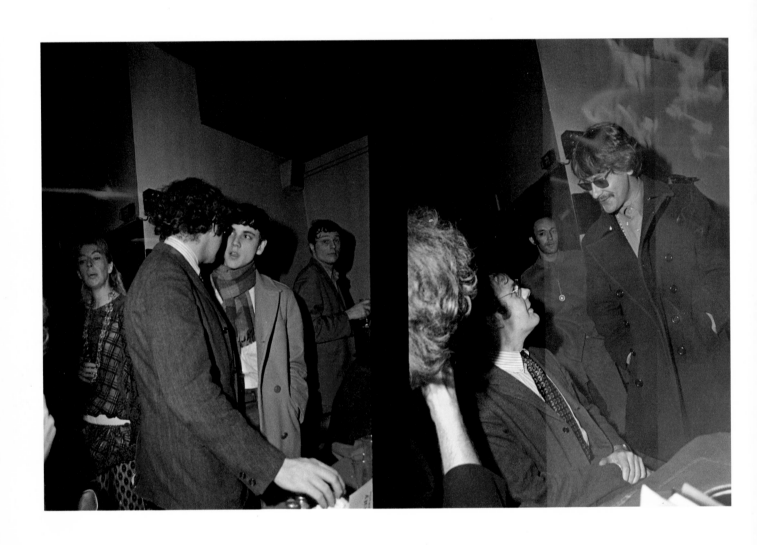

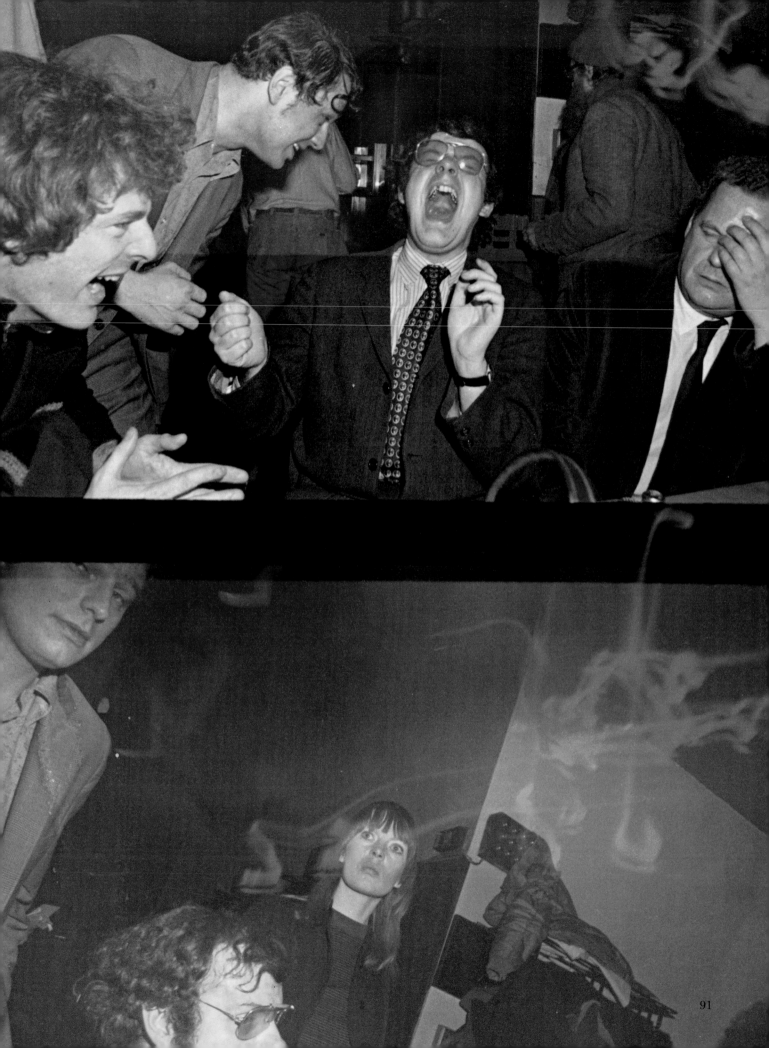

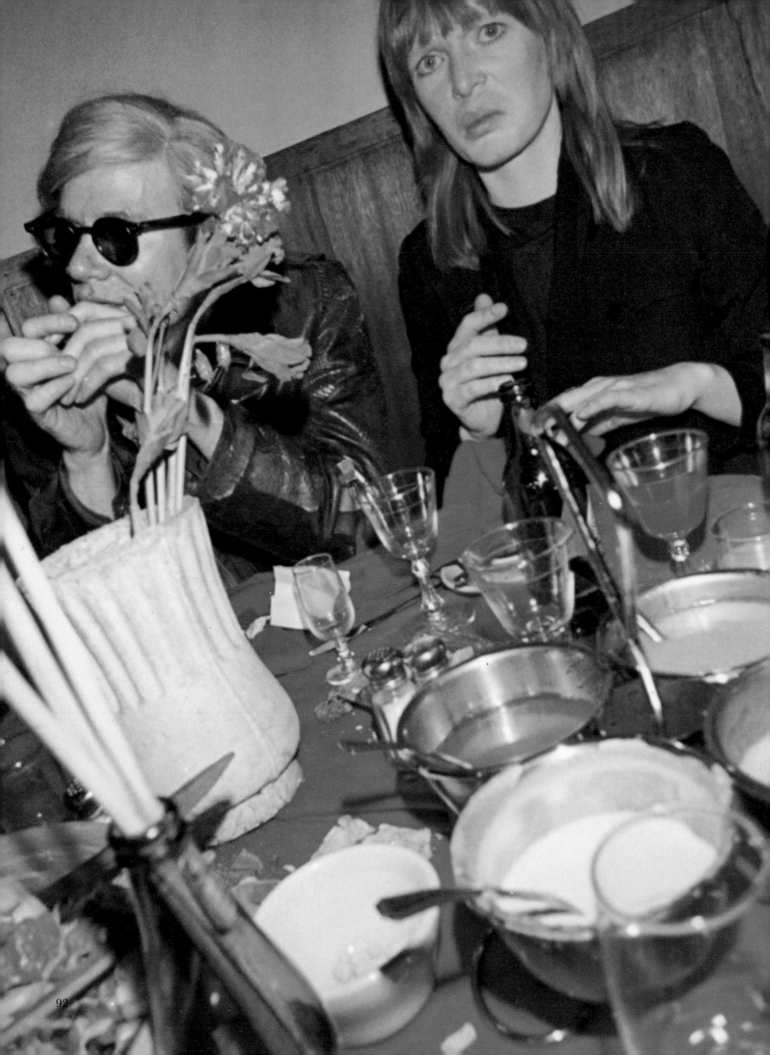

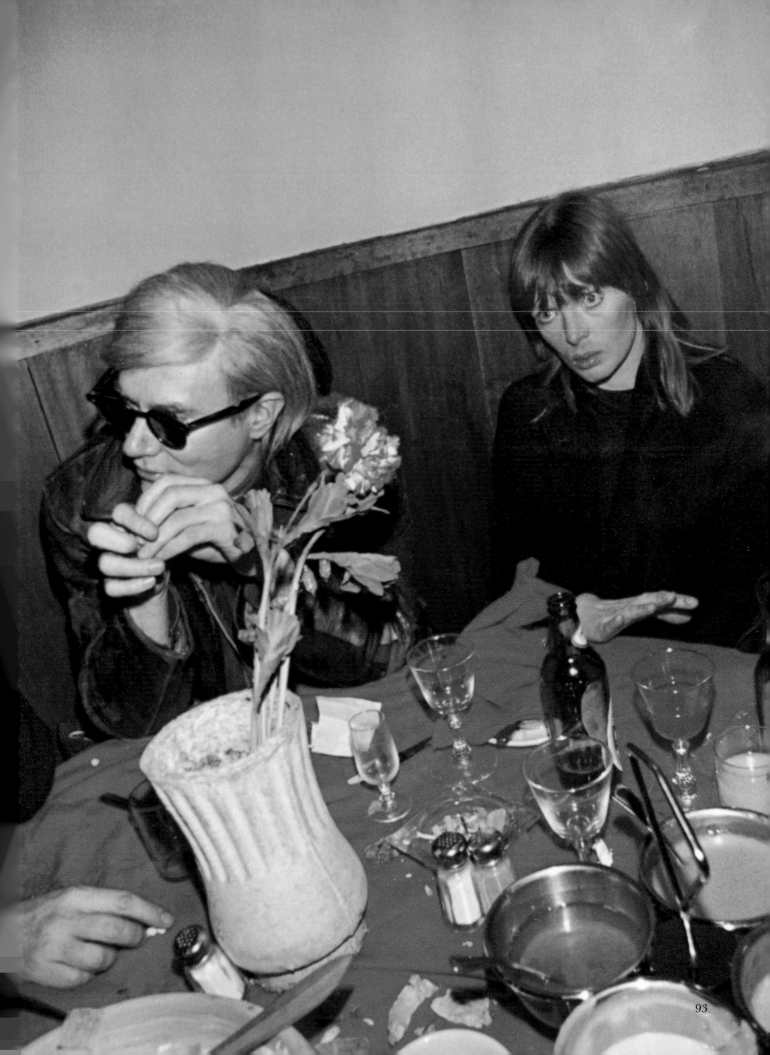

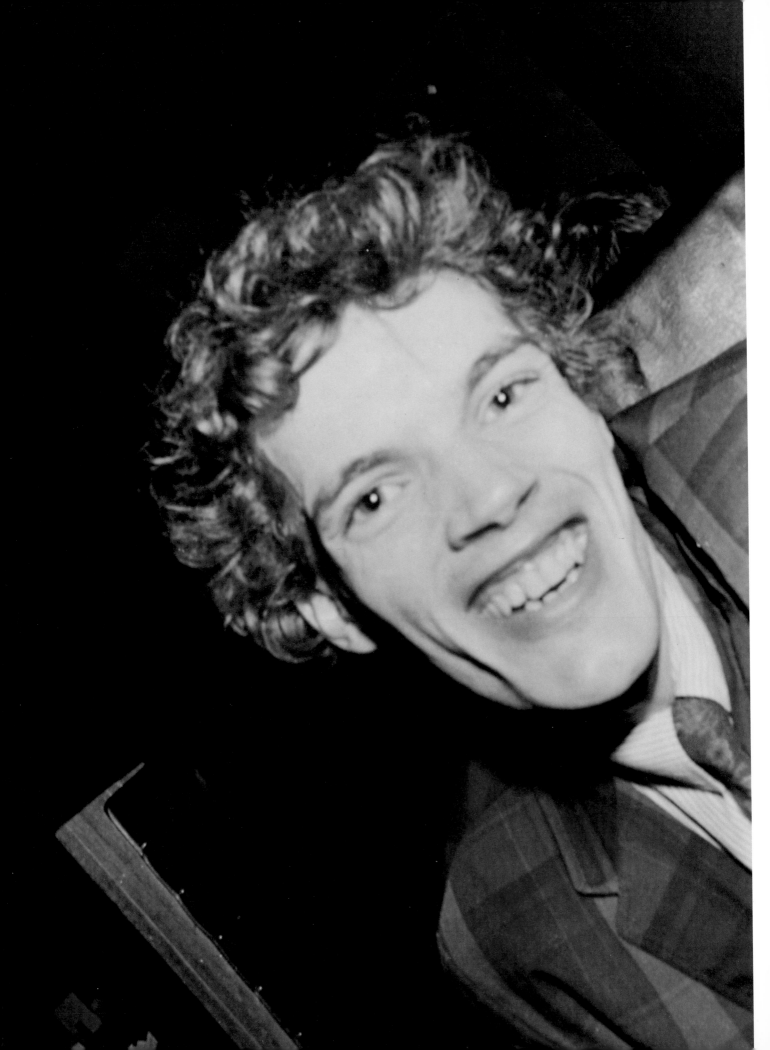

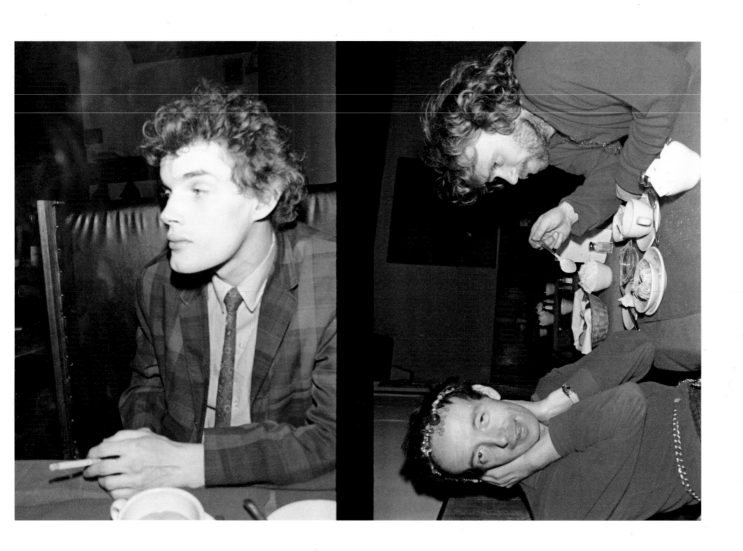

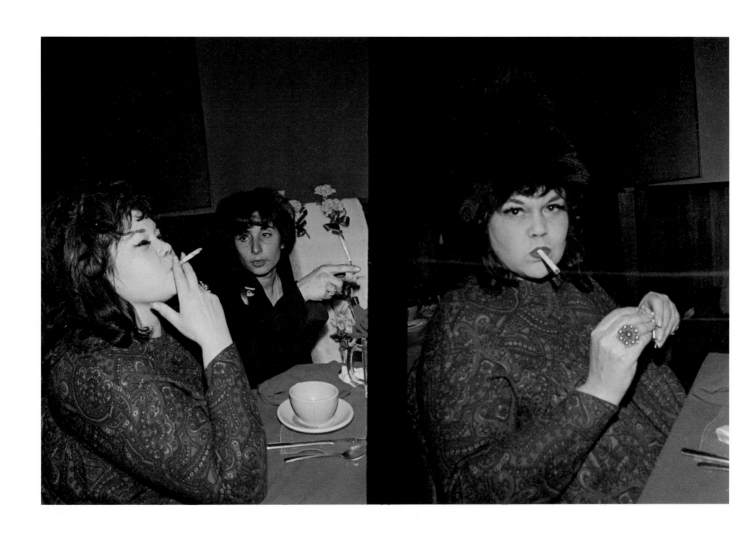

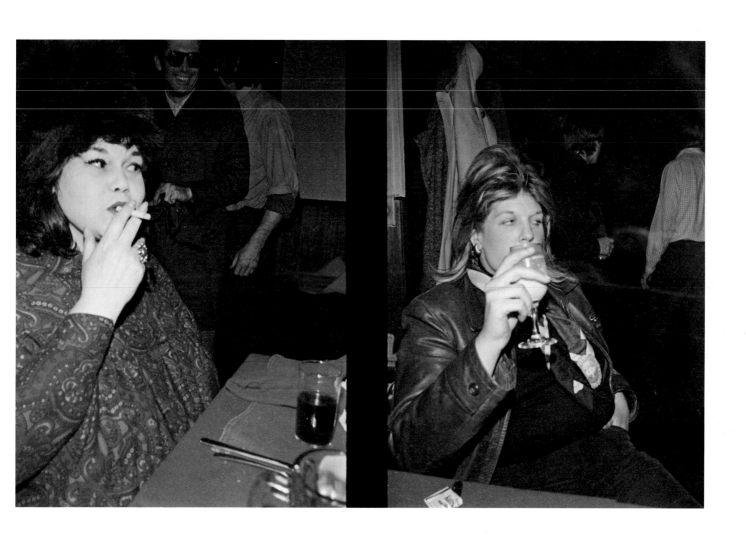

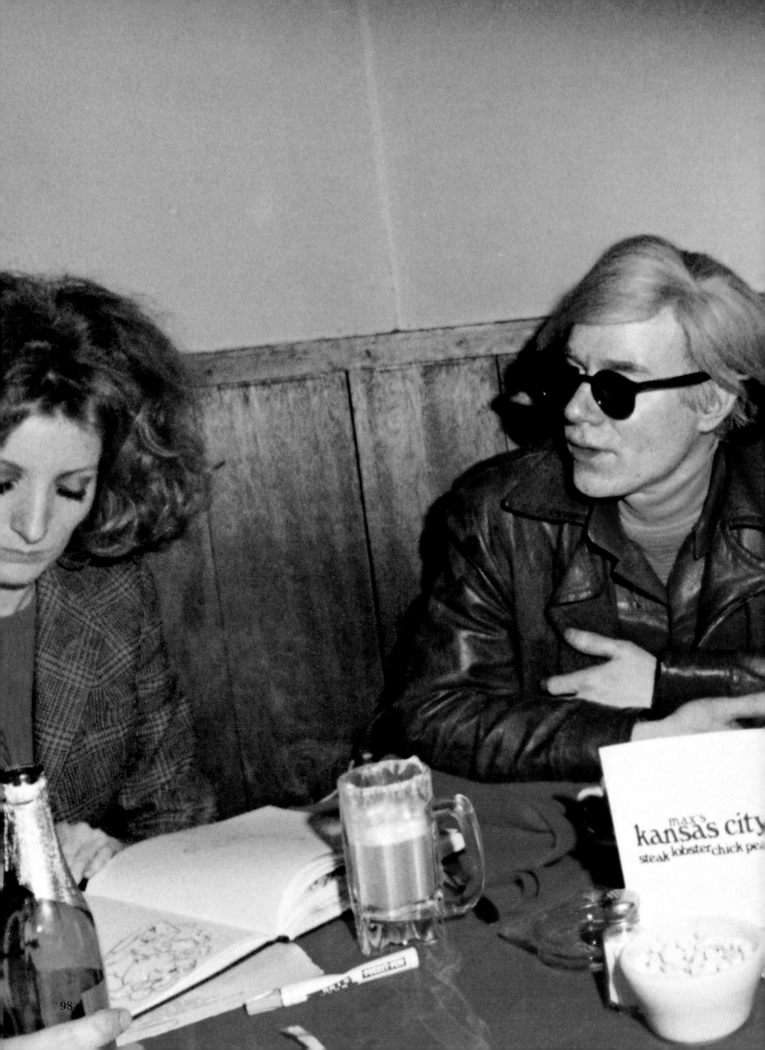

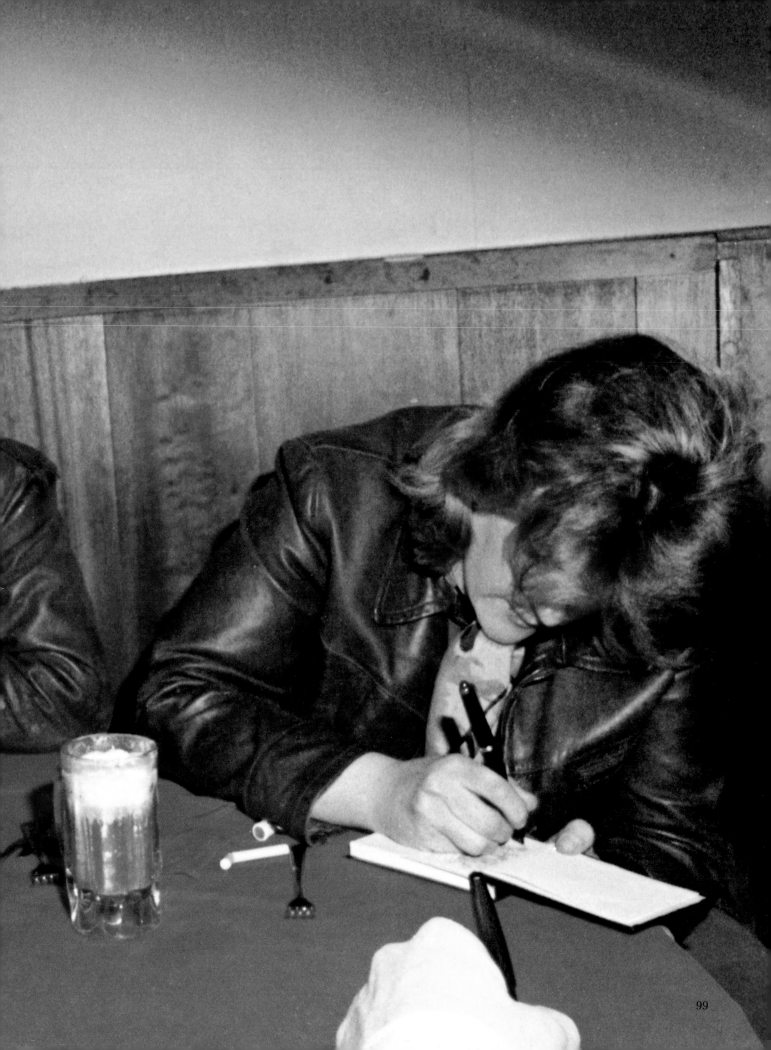

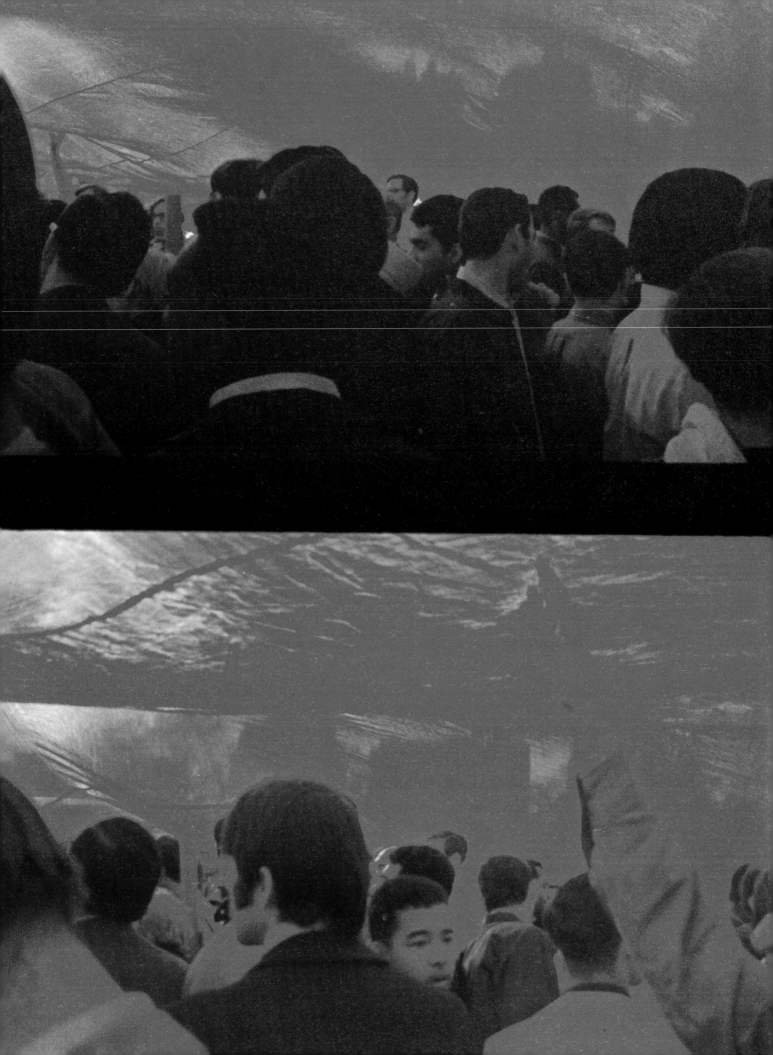

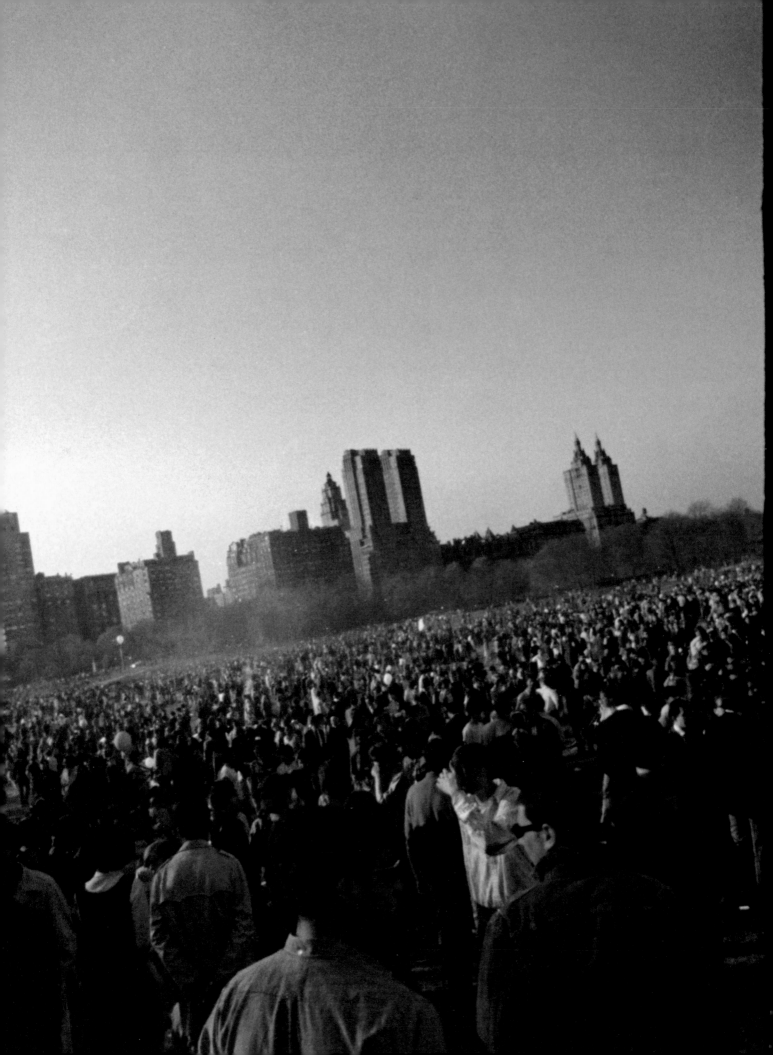

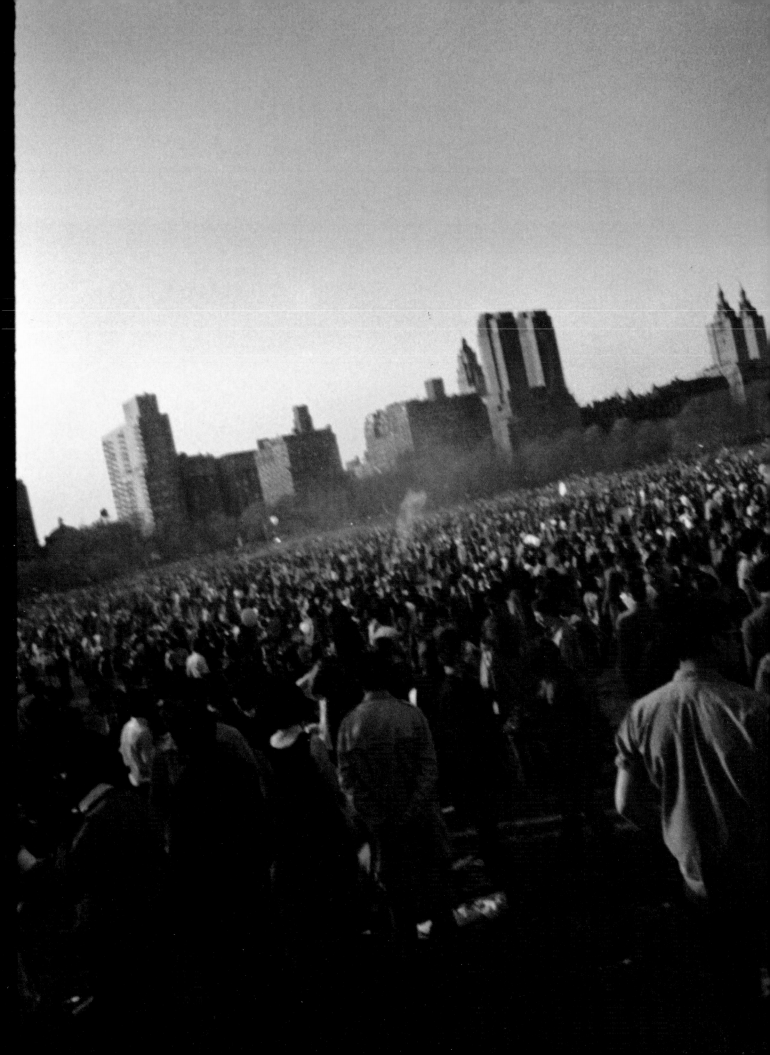

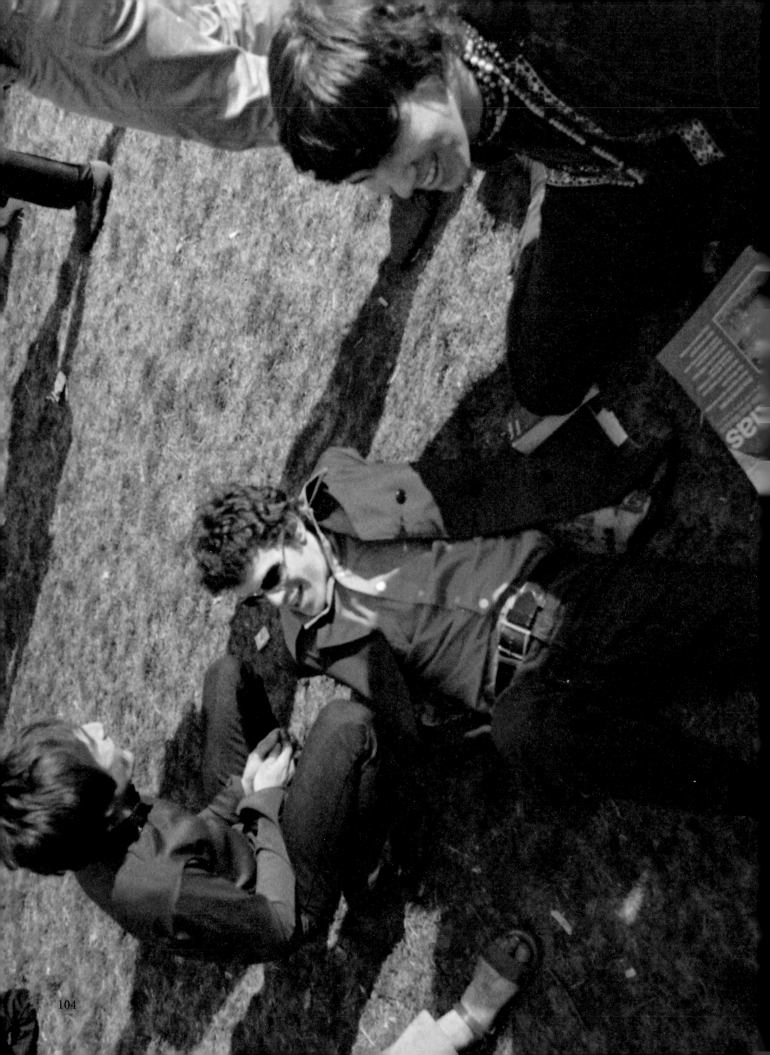

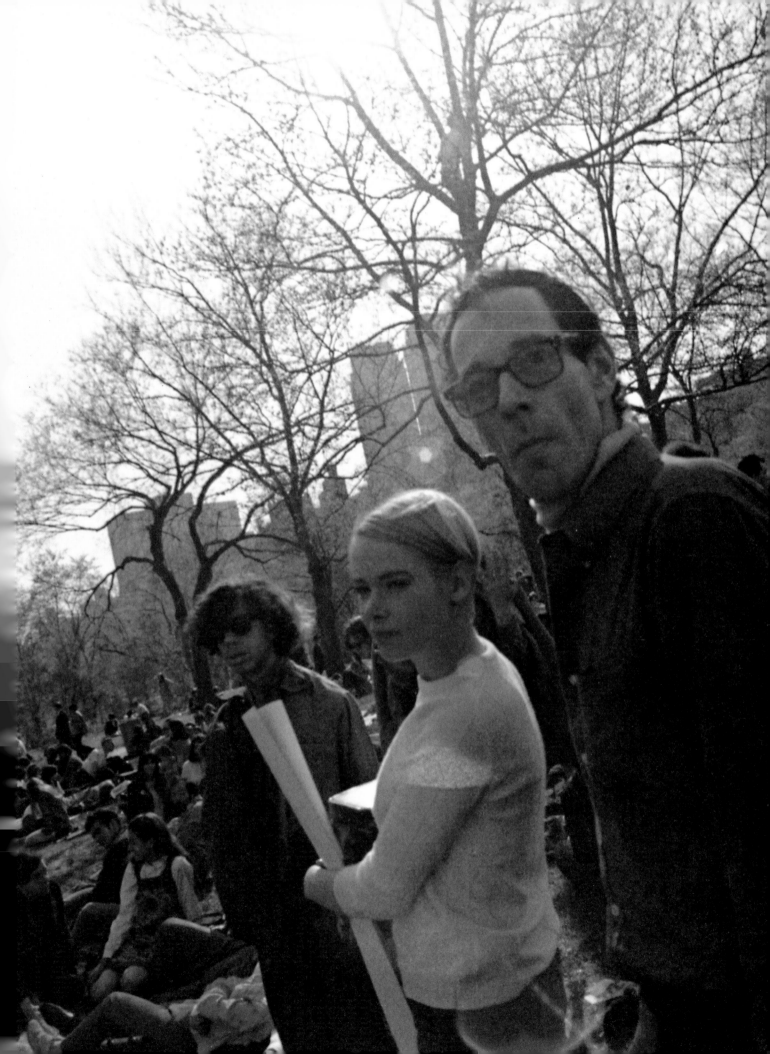

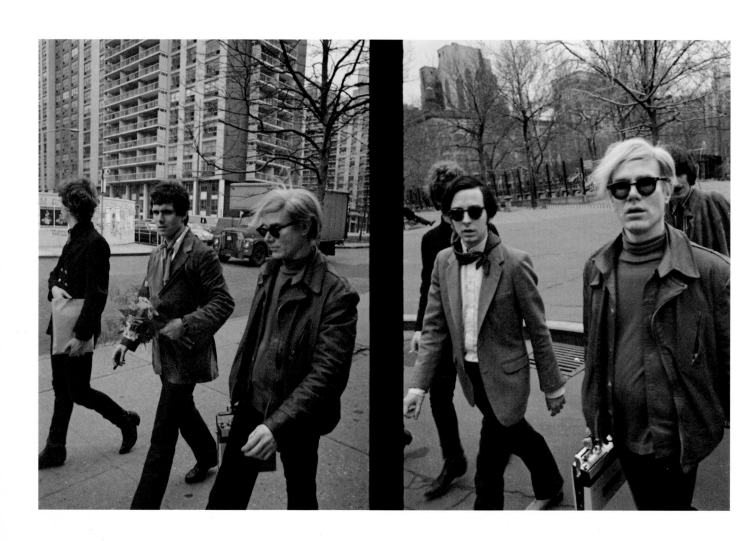

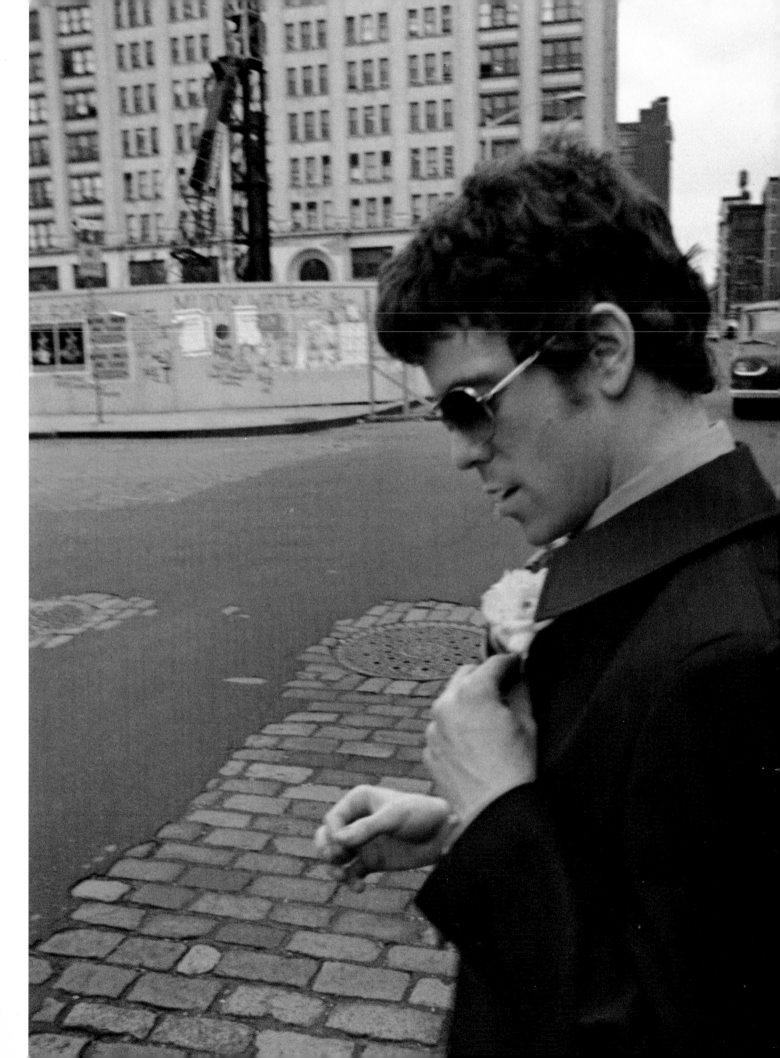

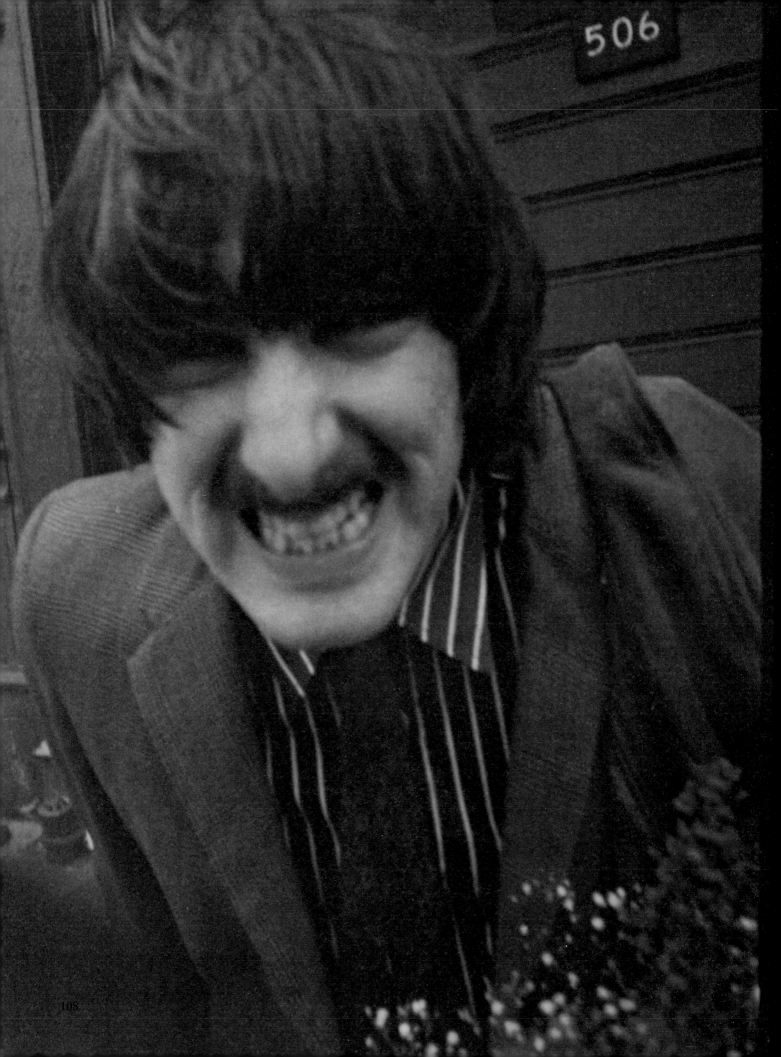

506

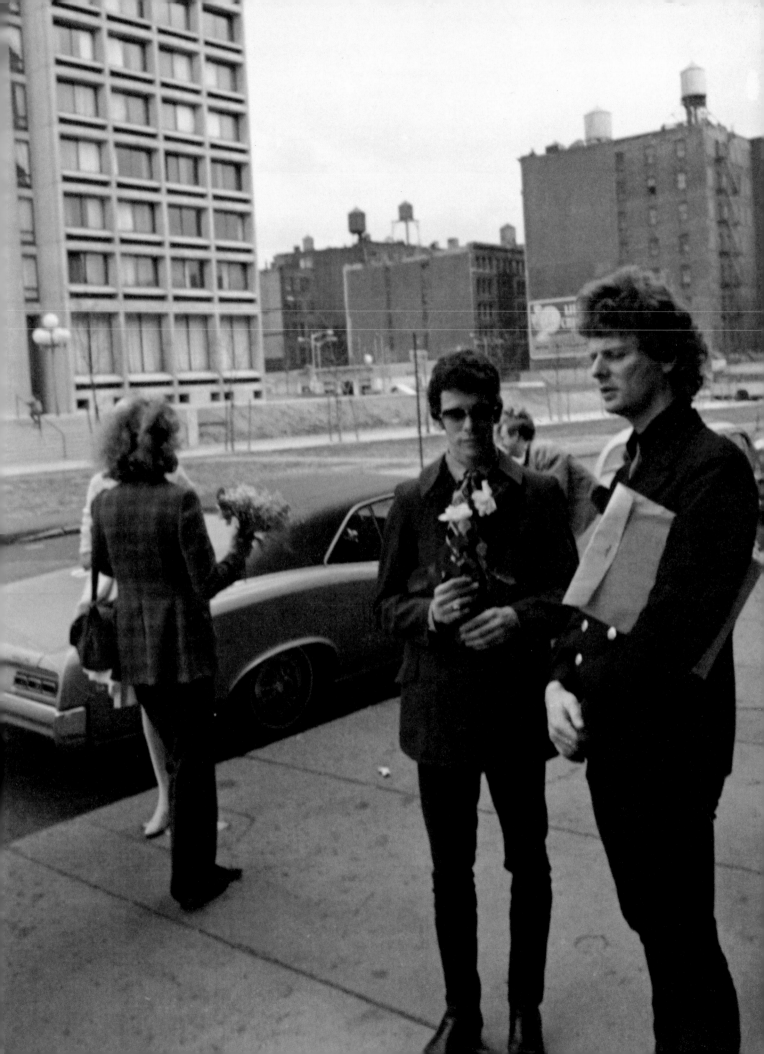

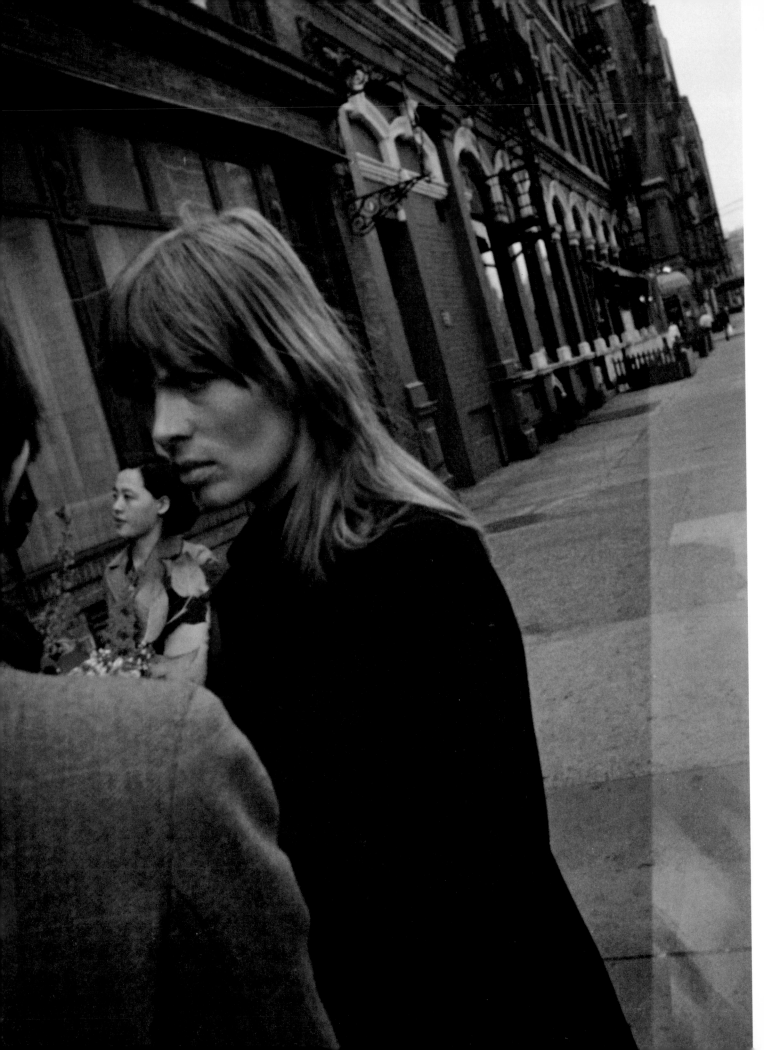

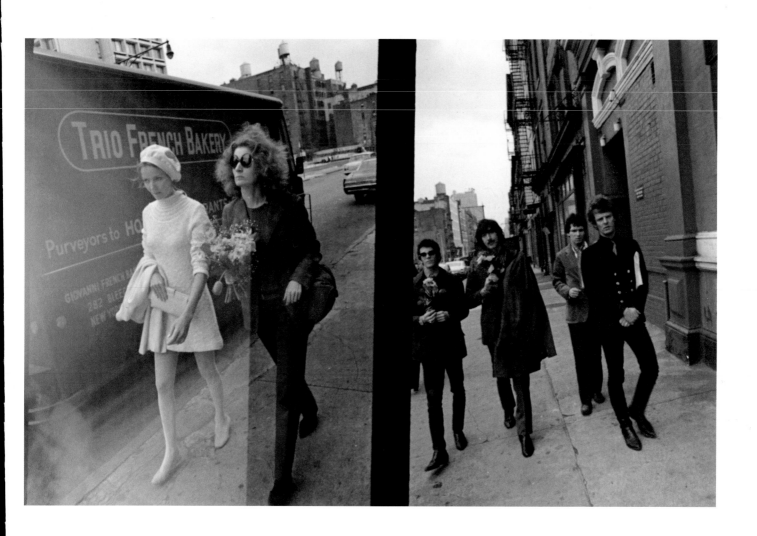

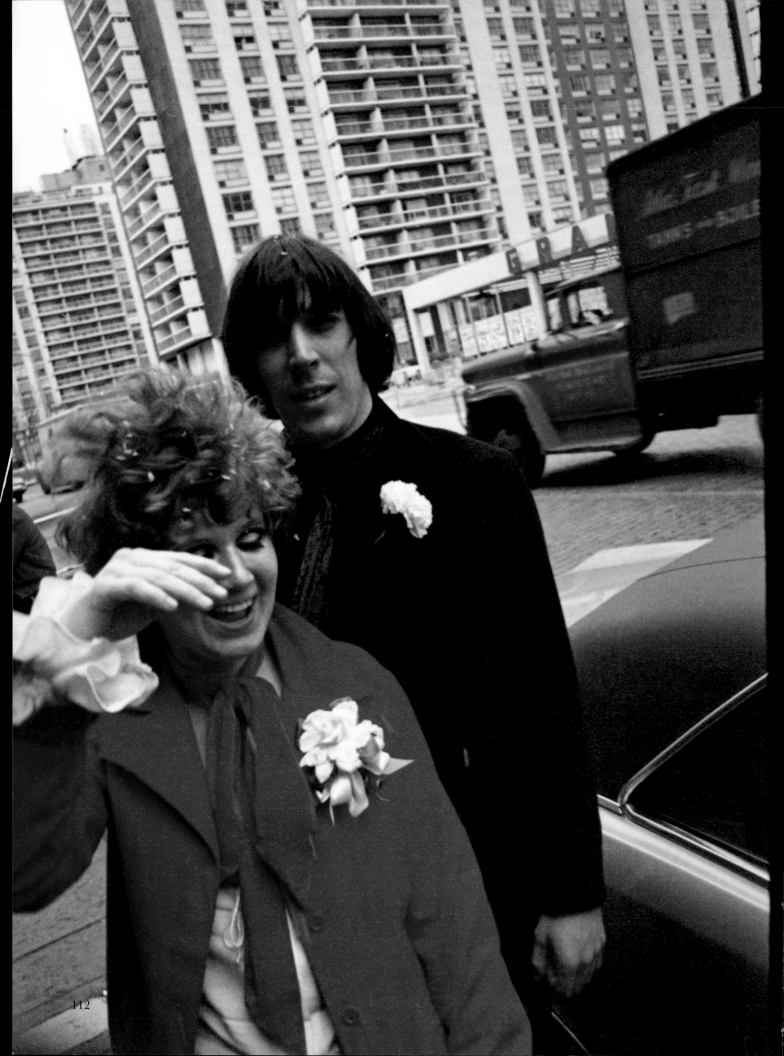

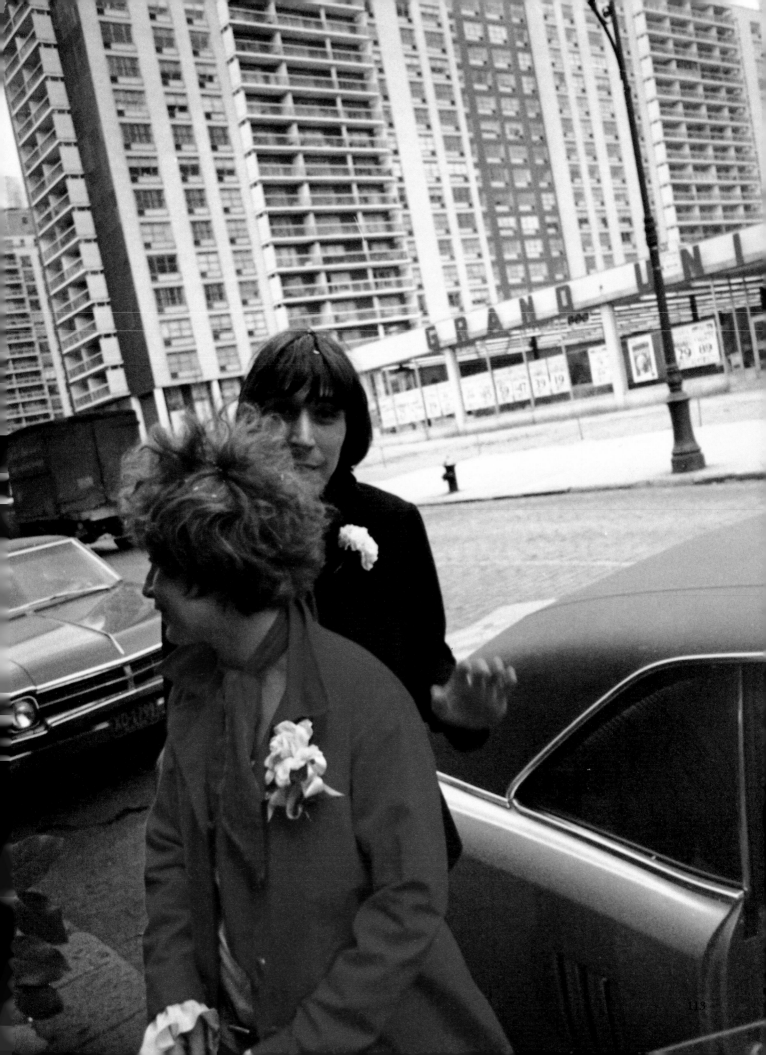

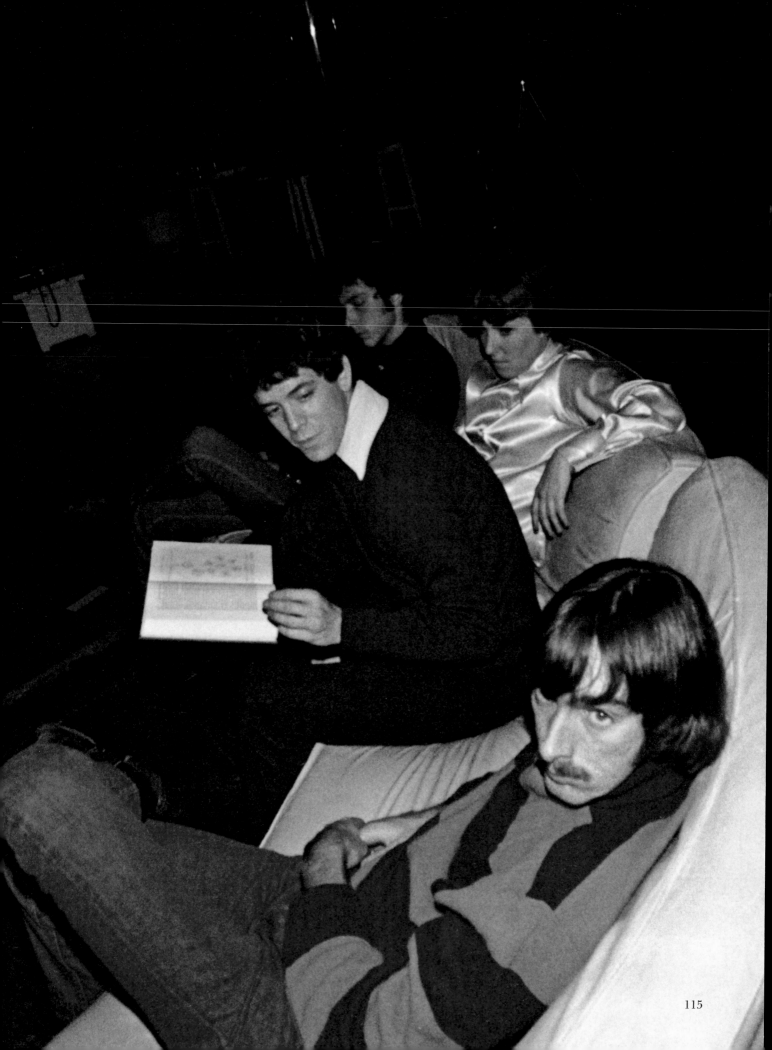

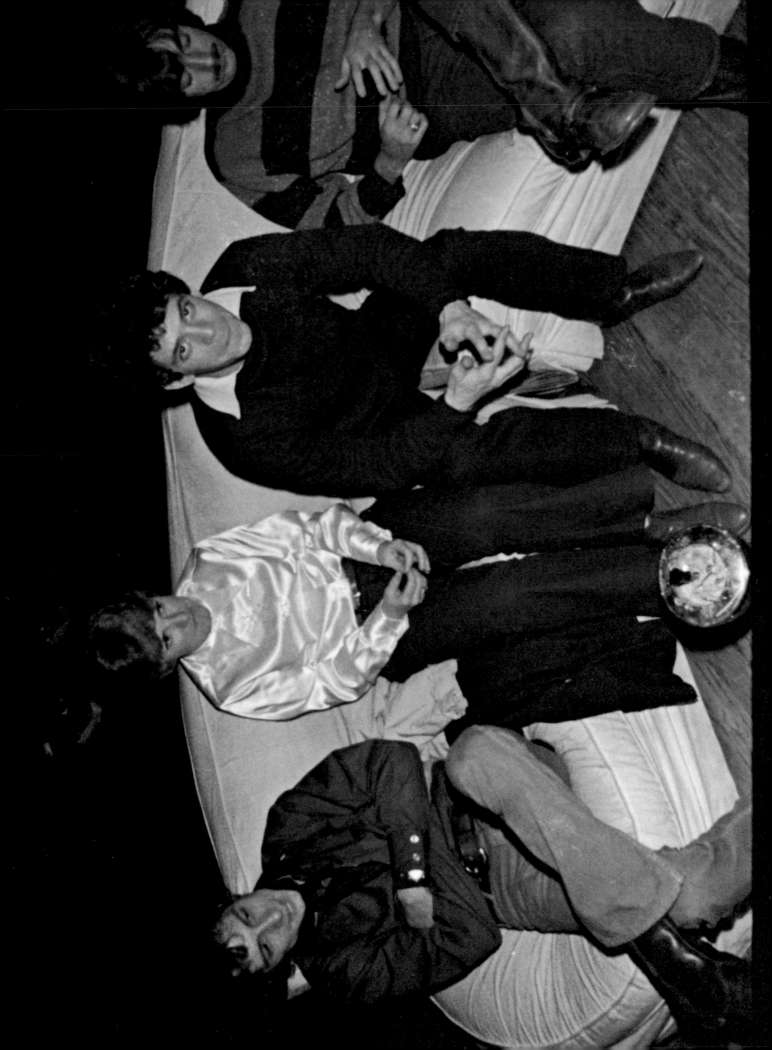

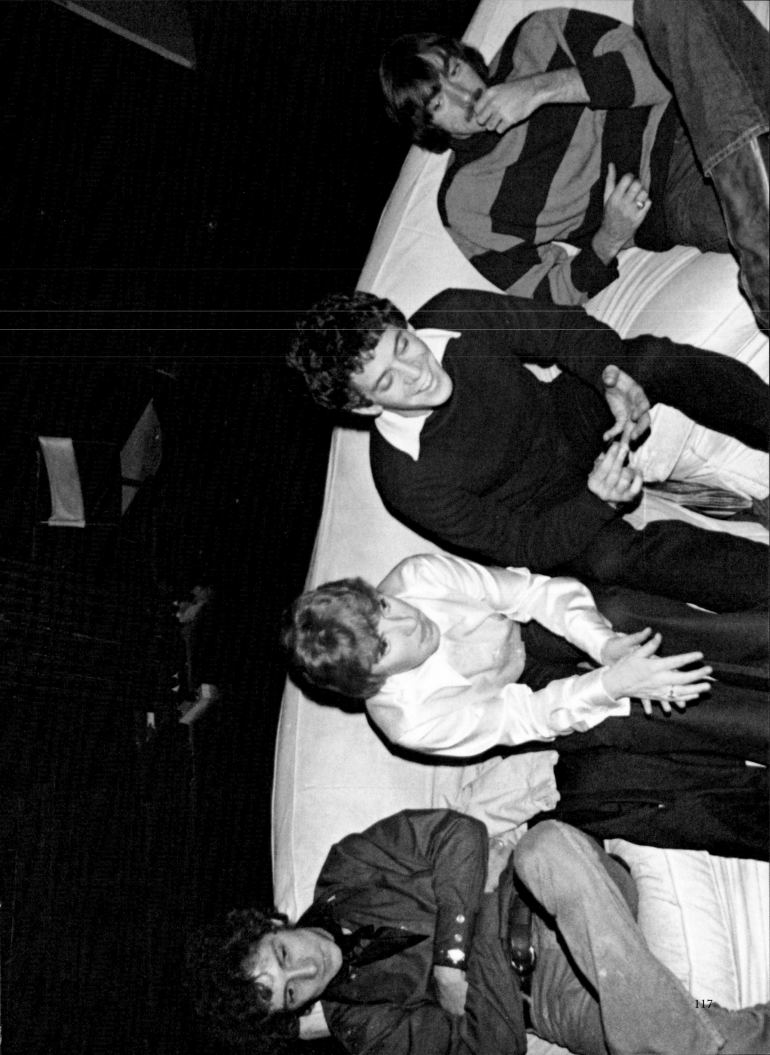

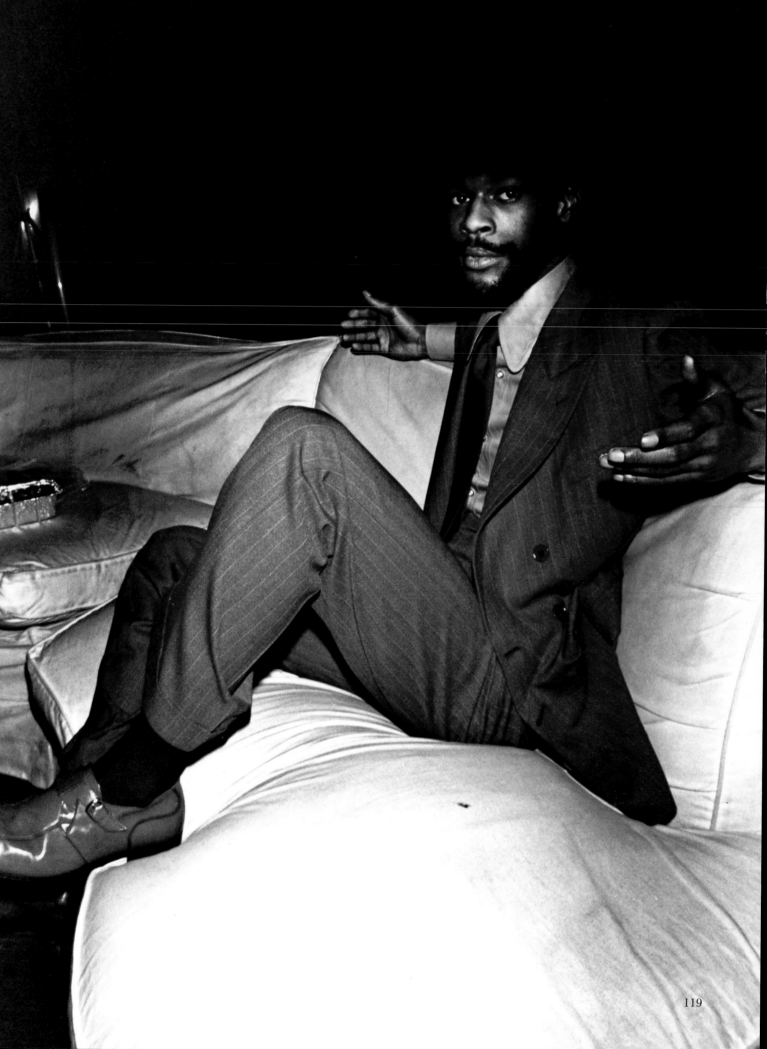

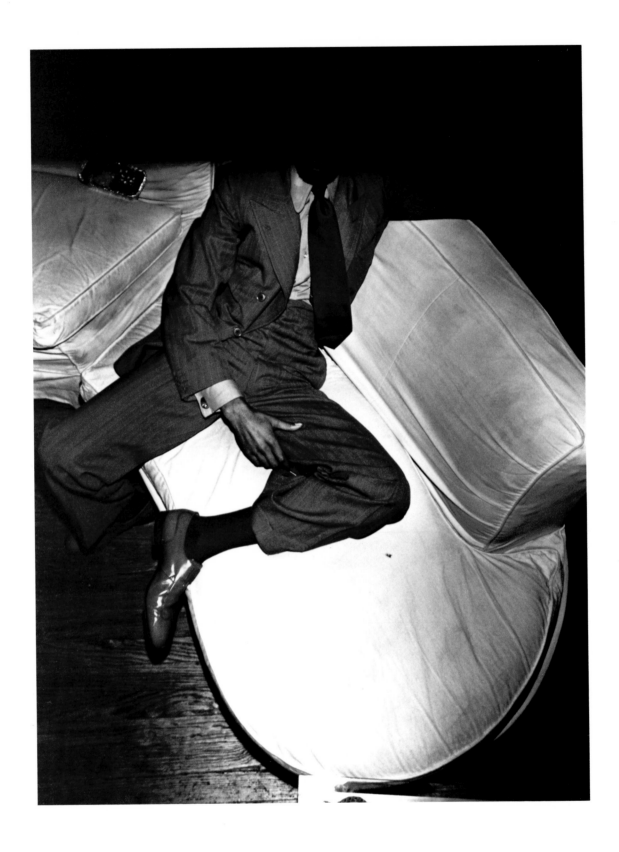

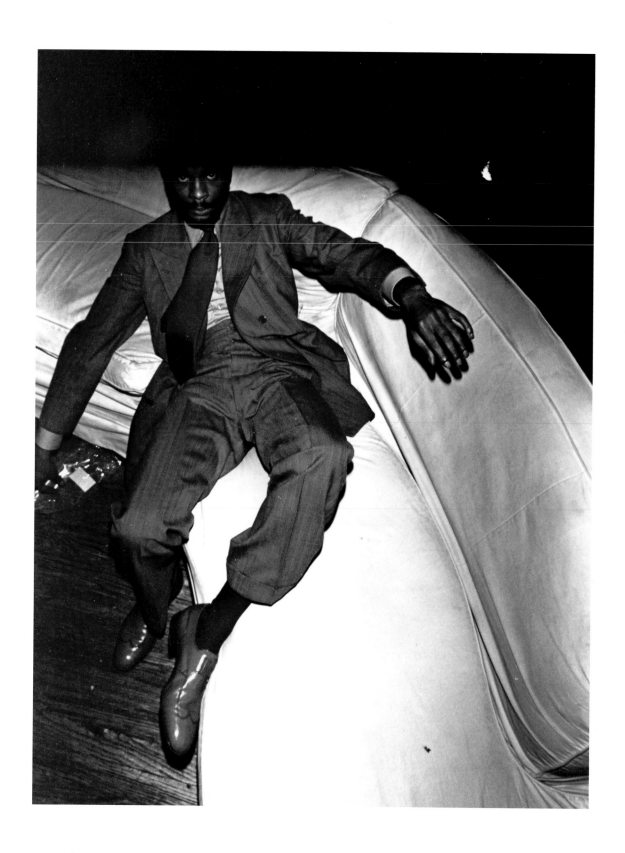

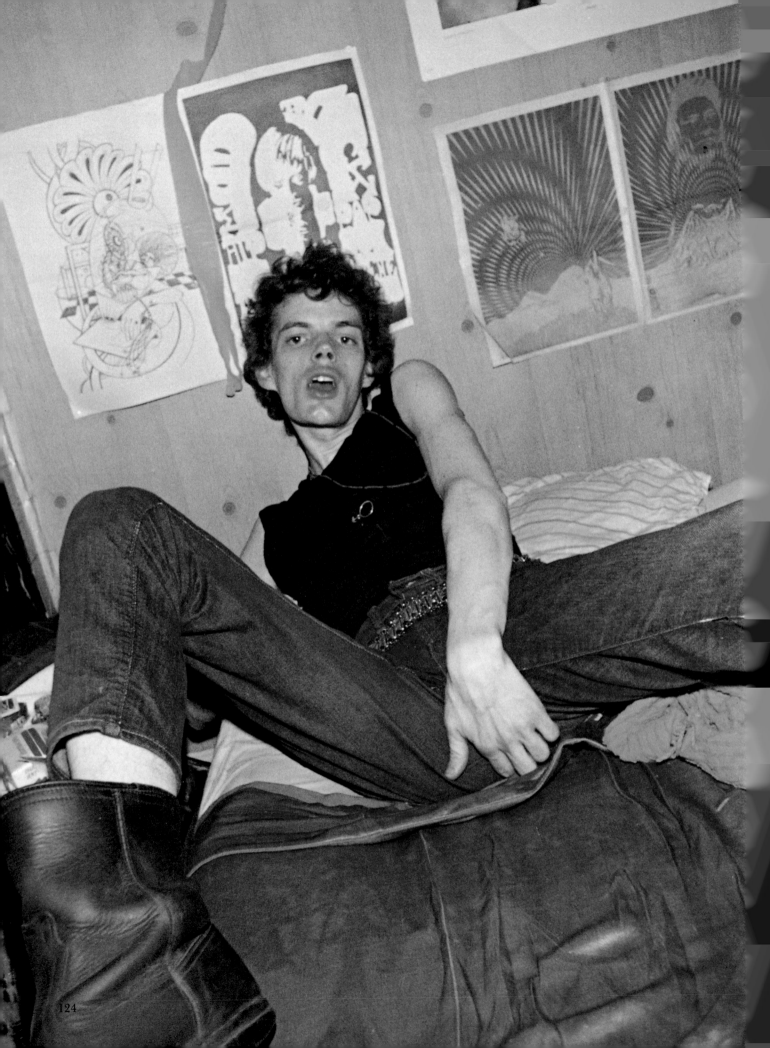

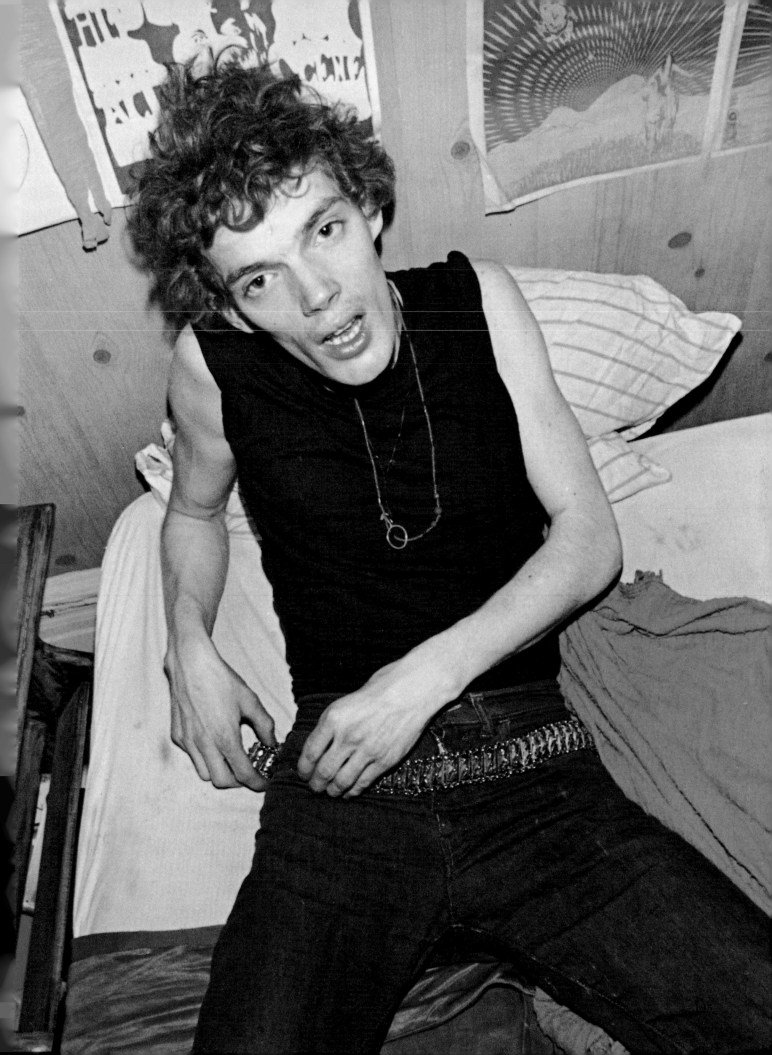

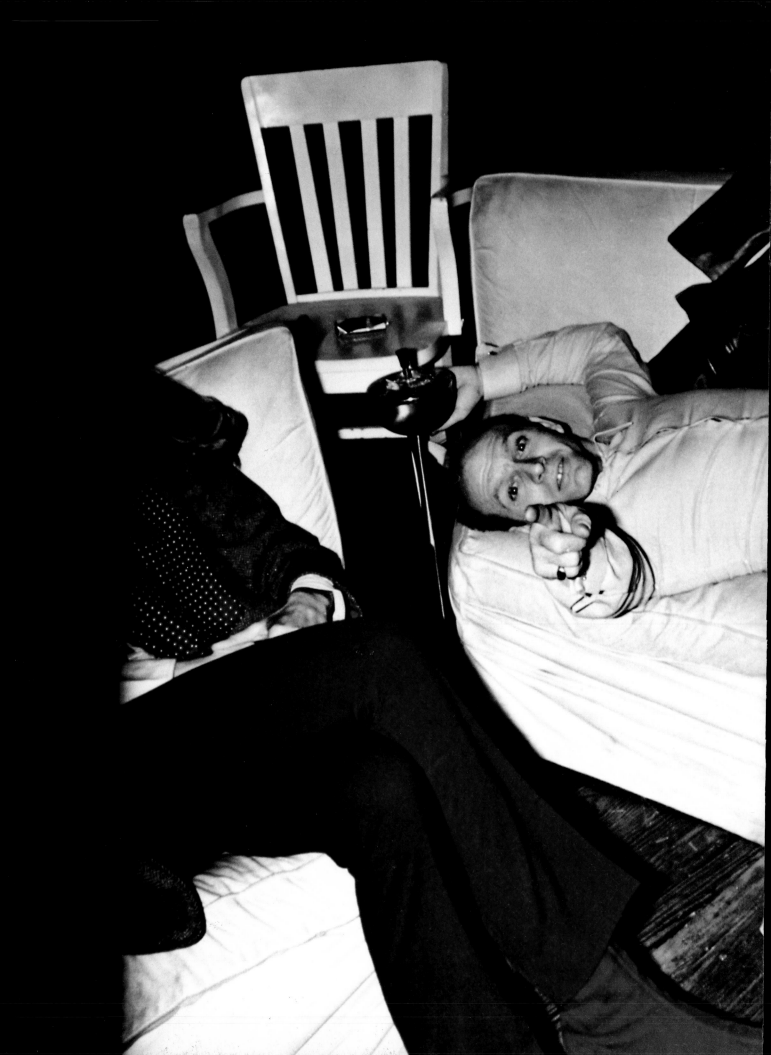

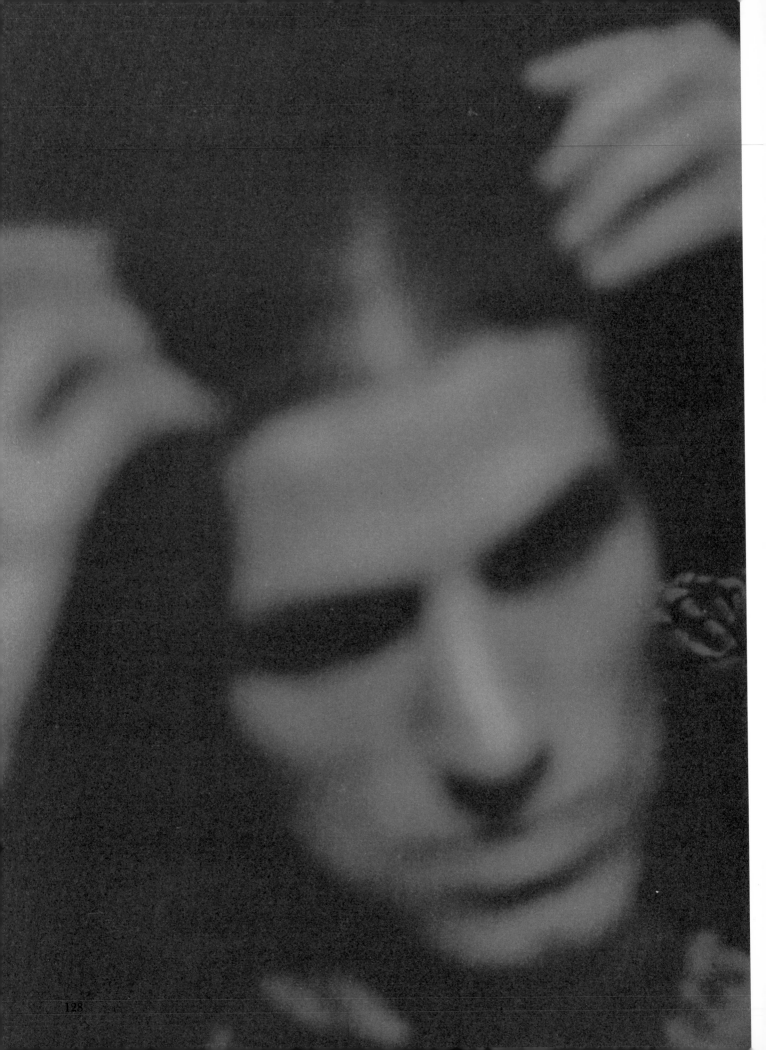

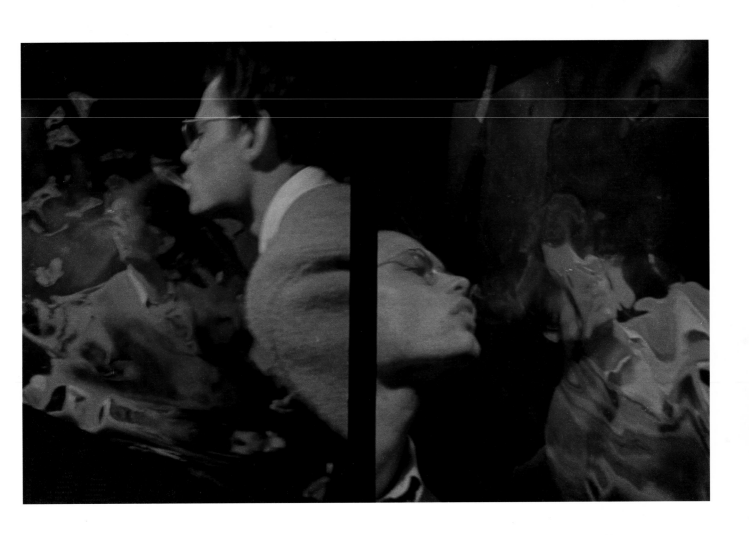

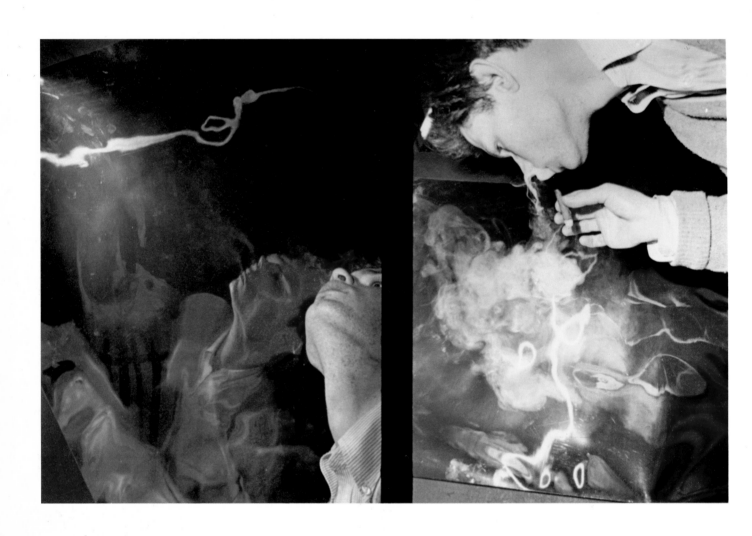

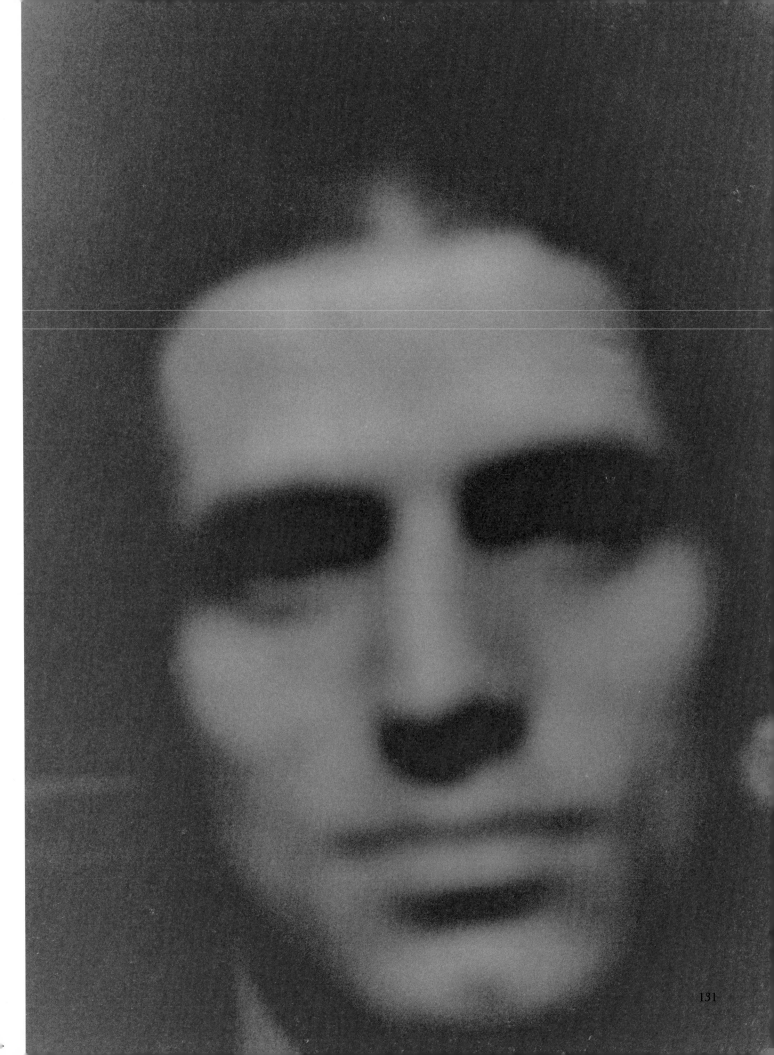

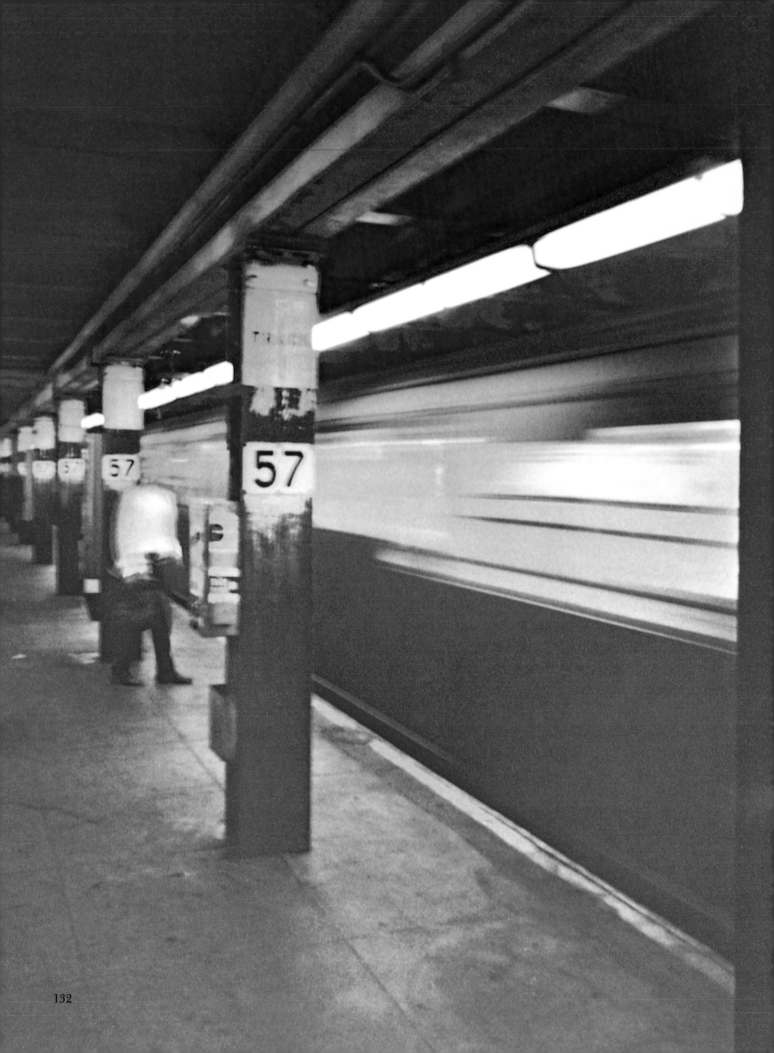

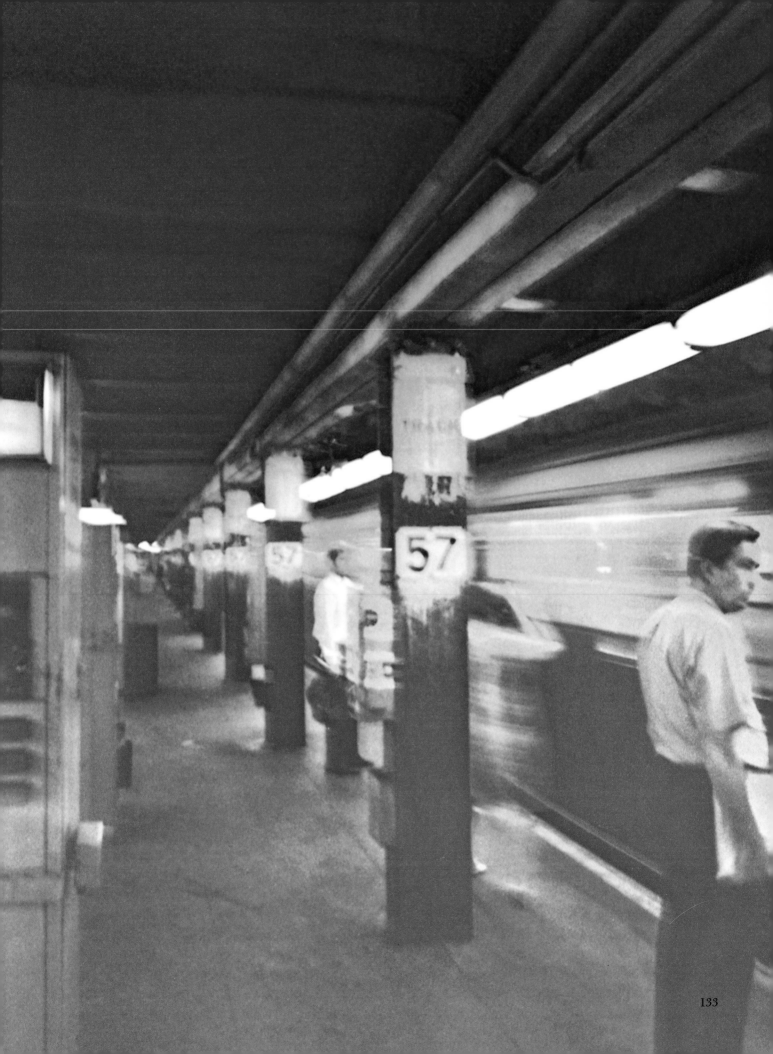

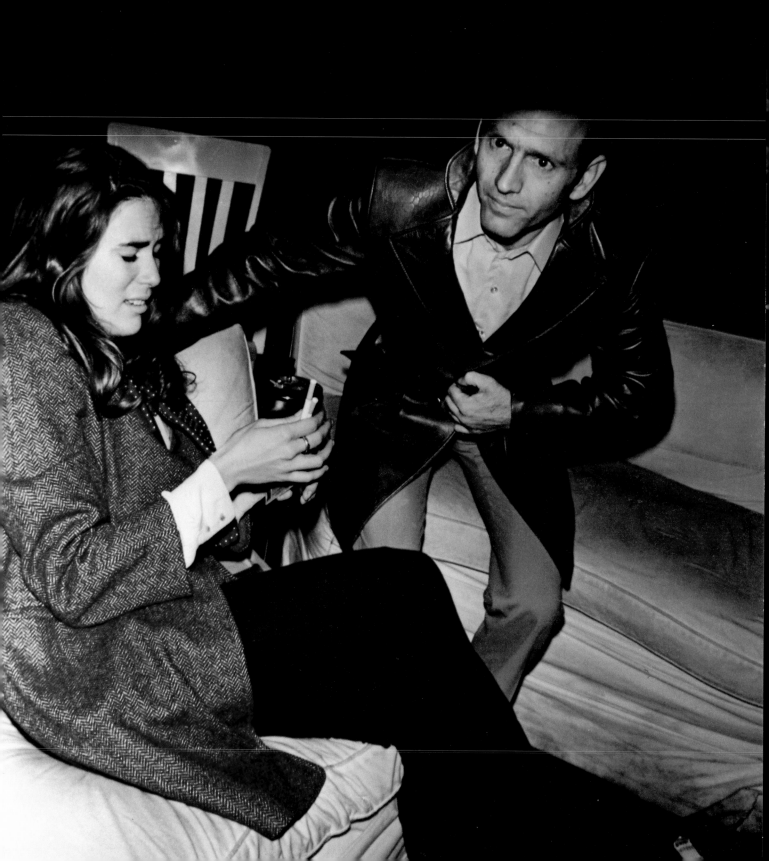

Plates